FRANCO-AMERICAN
LIFE & CULTURE
— IN —
MANCHESTER
NEW HAMPSHIRE

Franco-American Life & Culture in Manchester New Hampshire

Vivre la Différence

Robert B. Perreault

Charleston · London

Published by The History Press
Charleston, SC 29403
www.historypress.net

Copyright © 2010 by Robert B. Perreault
All rights reserved

Front cover: Seen here in 1987, our beloved green-arched Notre Dame Bridge (1937–89) served as the gateway to Manchester's Franco-American West Side. *Photo by Robert B. Perreault.*

Back cover, top, left to right: The mills of the Amoskeag Manufacturing Company and, beyond, the Franco-American West Side, seen from the Amoskeag Bank Building's roof, 1925. *Photo by Ulric Bourgeois*; Most immigrants came from villages that, in many ways, contrasted with New England's industrial cities such as Manchester. Fulford, Québec, circa 1908. *Photo by Ulric Bourgeois.*

Back cover, bottom: The view from atop Rock Rimmon, 1987, evokes memories of a Québécois village with the church as the nucleus of people's lives. *Photo by Robert B. Perreault.*

First published 2010

Manufactured in the United States
ISBN 978.1.59629.897.2
Library of Congress Cataloging-in-Publication Data
Perreault, Robert B., 1951-
Franco-American life and culture in Manchester, New Hampshire : vivre la différence / Robert B. Perreault.
p. cm.
Includes bibliographical references and index.
ISBN 978-1-59629-897-2
1. Franco-Americans--New Hampshire--Manchester--History. 2. Franco-Americans--New Hampshire--Manchester--Social life and customs. 3. Franco-Americans--New Hampshire--Manchester--Biography. 4. Manchester (N.H.)--History. 5. Manchester (N.H.)--Social life and customs. 6. Manchester (N.H.)--Biography. 7. Manchester (N.H.)--Ethnic relations. I. Title.
F44.M2P43 2010
974.2'8--dc22
2010039245

Notice: The information in this book is true and complete to the best of our knowledge. It is offered without guarantee on the part of the author or The History Press. The author and The History Press disclaim all liability in connection with the use of this book.

All rights reserved. No part of this book may be reproduced or transmitted in any form whatsoever without prior written permission from the publisher except in the case of brief quotations embodied in critical articles and reviews.

*To the memory of those who laid the foundations of Manchester's Franco-American community.
To those who today work tirelessly to preserve our heritage.
And finally, to those not yet born who shall one day inherit the fruits of their predecessors' dreams.*

CONTENTS

Foreword, by Aurore Dionne Eaton	9
Introduction and Acknowledgements	11
From Québec to Manchester	15
A Tale of Two Women	25
Father of the Franco-American Press	31
One Immigrant's View: Through the Lens of Ulric Bourgeois	37
French v. Irish: Why the Beef?	47
Before *Peyton Place*: In Search of the Real Grace Metalious	61
Old Parochial School Days	77
Neighborhood at a Crossroads	95
Quintessential West Sider of Yesteryear	107
Working with His Hands the Franco-American Way	115
A New Life for an Old Favorite: *The Innocent Victim*	121
Revisiting Eight Thousand Friends	129
Bibliography	135
Index	139
About the Author	143

FOREWORD

Like Robert Perreault, I am a Franco-American who grew up in Manchester, New Hampshire. Bob and I are the same age. We have moved along parallel tracks in many ways, especially during the 1950s. We often compare memories of growing up in Manchester. I, too, attended a bilingual school and was taught by kindly, dedicated, well-educated nuns. My family lived in the heart of the West Side, where we were nestled in a world that accepted our biculturalism as a natural thing. In fact, we saw it as an advantage. Having two cultures, two languages, certainly was better than having just one, we thought. We took it for granted that we could be fully and proudly American while still being "French." Our "English" life was the ship that would take us into the great, open and boundless world. Our Franco-American culture and heritage—especially the conservative and mystical French-Canadian manifestation of the Roman Catholic faith—was our anchor, our heart, our love.

Bob Perreault seems to have been born with a driving desire, and a natural ability, to observe and record the life around him. He keenly senses how the present comes out of the past in so many interesting and complex ways. In his writings, lectures and walking tours Bob blends firsthand observations with sound historical research, the intellectual underpinnings of a classical education and a talent for storytelling. There is another ingredient that makes Bob's "oeuvre" so special—he always treats his subjects with great respect, whether these are people he has personally encountered or the historical figures he has researched.

Foreword

This collection of essays presents important historical information about the Franco-Americans of Manchester. Bob's firsthand observations of a culture in transition, his personal memories and the poignant quotes from interviews enrich the content. I am grateful for the publication of this book. It is wonderful reading, and it speaks on so many levels. I thank Bob for making this unique and lasting contribution to the historical and cultural record of our city.

<div style="text-align: right;">

Aurore Dionne Eaton, Executive Director
Manchester Historic Association

</div>

INTRODUCTION AND ACKNOWLEDGEMENTS

Having published many articles and essays on the Franco-Americans of Manchester, my hometown, I've dreamed of compiling a sample into a single volume. But, for years, publishers showed no interest in such a project.

In 2008, when I least expected it, Lance Warren, commissioning editor of The History Press, a fairly new publisher I'd never queried, contacted me with an invitation: to produce a book about the Franco-Americans of Manchester. As luck would have it, I was otherwise engaged. The timing of this miraculous offer forced me to postpone accepting it. Fortunately, a year later, Brianna Cullen reopened her predecessor's file and—pardon the cliché—the rest is history.

Due to spatial limitations in the present volume, I've trimmed fat, but not substance, from the original versions of these writings. Having appeared in various publications over time, some pieces repeat certain information. Though redundant, this helps emphasize important facts. A few items have new titles, and I've also included a bit of previously unpublished material. Rather than rewrite older texts to fit a 2010 context, I've preserved their contemporary flavor by having added author's notes as updates. Consequently, "today" might refer to last year or to as far back as thirty years ago. For the sake of historical accuracy vis-à-vis easy comprehension by a modern Anglophone readership, I've included original French-language terminology along with the English-language nomenclature by which we've come to know certain institutions, places and concepts.

Introduction and Acknowledgements

All illustrations come from my private collection, which I've amassed through purchases, gifts or people and organizations having allowed me to copy their archival holdings for educational purposes. I acquired many images through my work on the Manchester Visual History Project in the late 1970s. Wherever possible, I've credited photographers, painters or donors of materials. Several photographs are my originals.

Individuals too numerous to name, both living and since deceased, contributed to these writings in their original forms. Some shared information through oral history interviews or casual conversations. Librarians, historians, teachers, editors and other professionals offered their expertise. Certain people's names appear within the body of a written piece. To all, I offer my deep appreciation. To those not mentioned, I apologize.

I must, however, acknowledge those connected directly to this book. I'm grateful to Jeff Saraceno, Brianna Cullen's successor, who, with compassion and understanding, made the transition run smoothly as we reached important deadlines. I thank editor Hilary McCullough and senior designer Natasha Momberger for making my book's text and graphics come to life.

Gary Samson, director of the Manchester Visual History Project, deserves credit for his generous contribution of copies of photographs from that collection, including those by Ulric Bourgeois and by several generations of Durette family photographers. I wish to recognize the late Antoinette Bourgeois, who gave us access to her father's images. Likewise, I thank Gerry Durette for granting me permission to reproduce all Durette photos.

I'm obliged to David Plante for having allowed me to quote from his novel, *The Country*. As a member of two writers' groups—the Blank Page, which meets at the Goffstown Public Library, and the Writers' Block, made up entirely of my former MFA in fiction and nonfiction classmates from Southern New Hampshire University—I have benefited from everyone's interest and support. Father John O'Donnell, my fellow Blank Pager, was kind enough to read my essay on French-Irish conflicts and to offer his insights into that once controversial topic.

My special thanks go to Aurore Dionne Eaton, executive director of the Manchester Historic Association, for her thoughtful foreword, the greatest endorsement a writer of local history could receive.

Introduction and Acknowledgements

Finally, for their encouragement throughout this project, I thank my son and daughter-in-law, Charles and Melissa Perreault, and especially my wife, Claudette, who also shared her family stories, gave me indispensable computer support and, as always, patiently endured the insanity that comes with being married to a writer obsessed with a mission.

FROM QUÉBEC TO MANCHESTER

Manchester is one of several New England mill towns that attracted immigrants from Québec, mostly between the Civil War and the Depression. For decades, the city enjoyed a friendly rivalry with Lewiston, Maine; Lowell, Massachusetts; and Woonsocket, Rhode Island, for the unofficial title of French-speaking capital of New England.

As did other ethnic groups, French Canadians came in search of a better life, away from their poor farming villages. New England's developing industries, especially its textile factories, needed operatives, while *habitants* (Québécois farmers) wanted jobs. It was a perfect match. Although early immigrants came on their own, mill owners soon realized that the Québécois were hard workers. Consequently, they sent agents to Québec to encourage more *habitants* to leave the soil for the mills, thus setting in motion a great migration.

The origin of Manchester's Franco-American community remains vague, as early sources offer varying information. Supposedly, in 1830, one Marie Jutras ran a boardinghouse in Amoskeag Village, actually part of Goffstown until 1853. Some claim that Manchester's first Québécois immigrant was Louis Bonin, who arrived in 1833. In the 1920s, Attorney Wilfrid Lessard researched the city's vital statistics records for the earliest documentation of French-Canadian presence in Manchester. He found the marriage of Louis Marchand and Sarah Robert dated August 19, 1839. More marriages appeared in the 1840s. By 1848, year of the founding of Manchester's first Roman Catholic parish, Saint Anne's, at least ten Québécois families

Franco-American Life and Culture in Manchester, New Hampshire

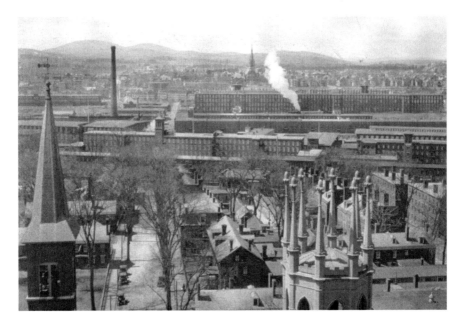

The mills of the Amoskeag Manufacturing Company and, beyond, the Franco-American West Side, seen from the Amoskeag Bank Building's roof, 1925. *Photo by Ulric Bourgeois.*

had settled here. One pre-1850 immigrant was Manchester's first French-Canadian proprietor, Joseph "Joe Bell" Bérard, whose home sat on Concord Street facing Vine, where the Centre Franco-Américain's parking lot sits today. In that era of strong anti-Catholic and anti-foreign sentiment, town clerks sometimes recorded incomplete information, if at all. Attorney Lessard found that the first birth, that of a boy, to a French-Canadian couple, Bertrand Chartrand and his wife, occurred only in 1851, while the first death, that of John Jacques, bears the date of January 11, 1853. As elsewhere, the Québécois arrived in great numbers only after the Civil War.

Those with minimal or no knowledge of English found few employment opportunities outside the textile industry. The majority went immediately to the Amoskeag Manufacturing Company—sometimes called simply "Amoskeag"—or to another textile plant, where openings usually existed. Undoubtedly, they suffered from alienation and homesickness, not to mention harsh working conditions. Nevertheless, immigrants considered themselves more fortunate in Manchester than back home.

In Québec, farming was a family project. Shocking by modern standards, this phenomenon also characterized the mills, since fathers and their

Vivre la Différence

The photographer's daughters watch their grandmother separate beans from straw in a winnowing basket. Valcourt d'Ely, Québec, circa 1908. *Photo by Ulric Bourgeois.*

children—some as young as eight—all worked, as did mothers with no little ones at home. Mill management realized that the best way to train a young laborer was to have him learn from his father or another male relative. Likewise, a mother might teach her daughter to weave or to spin. Common to all ethnic groups, this practice reduced the risk of misunderstandings among nationalities. It also eliminated the emergence of a united working-class front, which earned Manchester its reputation as a strikeless city, at least until 1922.

Due to their skillfulness, certain Québécois operatives became overseers, which rendered the atmosphere more tolerable for their compatriots. The management knew that a Francophone could better control his workers.

As news of American prosperity spread throughout Québec, priests, physicians, small merchants and other educated individuals began arriving in Manchester. All socioeconomic classes collaborated in the founding of institutions devoted to the preservation of the Catholic faith, the French language and Québécois traditions.

By 1869, Manchester's French-Canadian population numbered approximately 1,500. A newspaper, *La Voix du Peuple* (The Voice of the People), was founded. Despite its seven-month duration, it sowed the seeds for a press that flourished for a century. In 1871, Manchester's French Canadians created their first mutual benefit society, La Société Saint-Jean-Baptiste, and their first parish, Saint-Augustin. By then they totaled 2,500, but by 1880, this figure had risen to nearly 9,000. Up to then, they had always lived on the East Side of the Merrimack River.

In 1880, a major change took place. Vacant land on the river's West Side between Amoskeag Village and Piscataquog Village—formerly the farm of Robert McGregor, aide-de-camp to Revolutionary War leader General John Stark—was chosen as the site for a new parish, Sainte-Marie. Within twenty years, Manchester had a new French-Canadian neighborhood, sometimes referred to as a "Petit Canada." A Petit Canada was a Francophone village enclosed within an American industrial city, where immigrants became urbanized and adopted certain American customs while preserving their Québécois soul.

Depending upon whom one asks, the name of Manchester's Franco-American neighborhood and its boundaries have varied over the years. Anglophones called it McGregorville or simply the French West Side. Francophones referred to the area around Sainte-Marie's Church as Notre-Dame, though a small section nearby, known to Anglophones as the Flat Iron district, was called Petit Canada or "*en bas d'la côte*" (at the bottom of the hill). This is not to be confused with Whittemore Flats in the Gossler Park area,

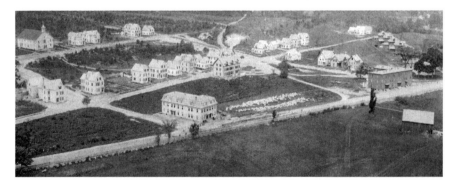

The budding Notre-Dame neighborhood seen from atop Amoskeag's 268-foot chimney, featuring the first Sainte-Marie's Church, upper left, 1883. *Courtesy of Dick Duckoff.*

Vivre la Différence

known to Franco-Americans as "Le Flatte." Meanwhile, there didn't seem to be any specific French name for the more modern residential area farther west, what became the territory of Saint-Jean-Baptiste Parish—renamed "Parish of the Transfiguration" since the merger with Saint-Edmond Parish.

The growth of the French-Canadian population meant new parishes, more newspapers and various societies. To assure the preservation of the Catholic faith and of the French language, parishes employed religious orders from Québec and France to teach in the parochial schools. Manchester eventually had eight French-language parishes, the largest number of any city in the United States. While the Franco-American West Side and its more recent counterpart, Pinardville, incorporated four Franco-American parishes to accommodate a heavy concentration of Francophones, Manchester's East Side also had four such parishes. Manchester's map shows that the East Side is considerably larger than the West Side. Consequently, although people consider the West Side *the* Franco-American neighborhood, it is possible that the East Side had as many, if not more, Franco-Americans, but they were more thinly spread.

Manchester also gave birth to the first New England- and Québec-wide federative fraternal life insurance society, L'Association Canado-Américaine (ACA), in 1896; the first credit union in the United States, La Caisse Populaire Sainte-Marie (St. Mary's Bank), in 1908; and one of a handful of New England's daily French-language newspapers, *L'Avenir National (The National Future)*, 1894–1949.

The majority of Québécois continued to work in the mills, as well as in shoe factories established toward the end of the nineteenth century. Having gathered a bit of capital, enterprising laborers created small businesses: grocery stores, bakeries, barbershops, pharmacies, hardware stores, blacksmith shops, stables, clothing stores and funeral parlors. Others became carpenters, painters and masons. Women managed boardinghouses or boutiques or became milliners, seamstresses, office workers or teachers. Anyone who learned English could establish an office or a business in Little Canada or downtown among Anglophone merchants and professionals. Some entered politics. By 1895, roughly seventeen thousand of Manchester's fifty-five thousand inhabitants were of Québécois origin or descent. Consequently, it was not difficult to get elected. Between 1918 and 1990, the mayoralty of Manchester was almost

always occupied by a Franco-American. Despite their success, many who transcended the working class retained the conservative Québécois spirit and mindset of their rural forebears.

Gradually, the Québécois in Manchester and throughout New England settled in the United States on a permanent basis. Having founded their own institutions, having become U.S. citizens, they no longer considered themselves French Canadians in the original sense. By the turn of the century, they had become known as Franco-Americans.

As elsewhere, Manchester's Franco-Americans underwent trials and changes. Many were victims of World War I and of the 1918 influenza epidemic. Then came the federal government's Americanization movement, an attempt to abolish all foreign languages and cultures, despite the fact that French had been spoken in North America—including much of what became the United States—since the first French expedition landed in North Carolina in 1524.

Meanwhile, problems that had plagued New England's textile industry for several decades began to manifest themselves in Manchester. Southern factories, where cotton grew and labor remained inexpensive, manufactured cloth at a lesser cost. To compete, New England's mills increased work hours and reduced wages. Demonstrations, riots and strikes followed. To avoid these difficulties, Amoskeag relied on its corporate paternalism program, which offered benefits designed to appease workers and retain their loyalty while simultaneously controlling them. Although World War I temporarily suppressed labor unrest by providing work orders, after the war, the economic threat returned. This time, Amoskeag could not escape. In 1922, a nine-month strike paralyzed the city, whose economy depended largely upon Amoskeag, Manchester's largest employer. Besides being divided over the strike, Franco-Americans suffered in greater numbers than any other ethnic group, as they constituted nearly half of Amoskeag's seventeen thousand employees.

In the years following the strike, Amoskeag gradually reduced its workforce, a move that accelerated during the Depression. Eventually, more strikes ensued, and finally, after a reign that had lasted for more than a century, Amoskeag closed its doors. The year 1936 marked the end of an era that had made Manchester one of the world's leading textile centers.

Vivre la Différence

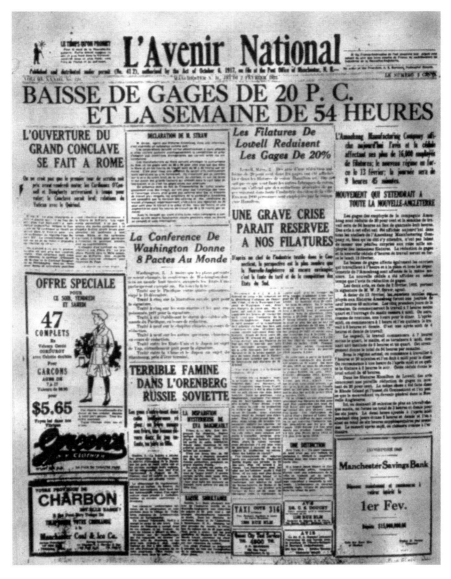

L'Avenir National headline announcing Amoskeag's 20 percent wage reduction and forty-eight- to fifty-four-hour workweek increase, resulting in the strike of 1922.

Along with the rest of the country, Manchester recovered from its economic woes due partly to World War II but also thanks to Amoskeag Industries, an organization founded by one of Manchester's leading Franco-American businessmen and former mayors, Arthur E. Moreau. Amoskeag Industries

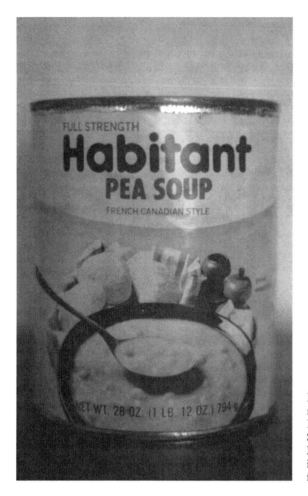

Remember the slogan?: "You mustn't ever put water in a Habitant Soup." Habitant Soup Company, Amoskeag Millyard, 1938–83. *Habitant* is the Québécois word for farmer.

purchased the bankrupt millyard property and resold it to a variety of manufacturing firms. One of these was started by newly arrived Québécois businessmen Philias Morin and the Limoges brothers, Albert and Rémi: the Habitant Soup Company, makers of French Canadian–style pea soup and other varieties.

During World War II, a Manchester Franco-American, René Gagnon, was one of six American flag raisers atop Mount Suribachi on Iwo Jima Island in 1945. After the war, many more Franco-Americans rose into middle-class mainstream America while continuing to more or less maintain their bilingual institutions into the 1960s. As did other ethnic groups, they sometimes suffered discrimination and prejudice. Therefore, some consciously rejected the French language and their ancestral traditions,

Vivre la Différence

while others merely abandoned them gradually over time. By the early 1970s, however, after a decade that revolutionized the nation and especially its younger generation, many Franco-American institutions had either disappeared or been transformed to the point where their linguistic and cultural identity barely remained.

Conversely, due to the historic fervor that inspired most Americans just prior to and since the U.S. Bicentennial, a significant number of Franco-Americans experienced a cultural revival. Neither a return to traditions nor even to the French language, it was rather an assertion of ethnic pride. This resurgence manifested itself in an interest in genealogy, cultural activities and the study of French history and literature of the United States. In Greater Manchester, the creation of several organizations and projects attests to this

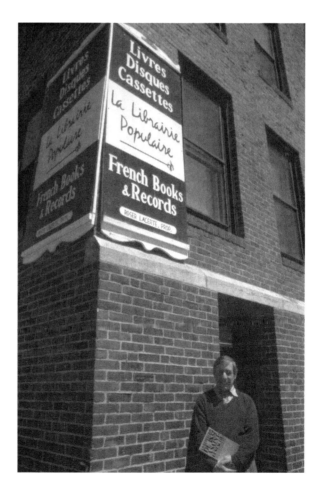

La Librairie Populaire owner Roger Lacerte, 1988. He also hosts a Sunday morning musical program, *Chez-Nous*, on WFEA AM 1370. *Photo by Robert B. Perreault.*

cultural recycling: the American-Canadian Genealogical Society in 1973; a book publisher, the National Materials Development Center for French (1975–82); the opening in 1977 of a French bookstore, La Librairie Populaire; beginning in 1987, the broadcast of more than five hundred weekly episodes of the ACA-sponsored French-language TV program *Bonjour!*; and the founding of the Centre Franco-Américain in 1990.

A small number of Franco-Americans have chosen to continue speaking French and affirming their roots more strongly than ever. They have accomplished this without help from traditional Franco-American institutions such as churches and parochial schools that have either disappeared or been completely anglicized—with one exception in Manchester, ironically, an East Side parish, Saint-Antoine-de-Padoue (Saint Anthony), which continues to hold one Sunday French Mass. It is thanks to these dedicated few that Franco-American culture lives on.

A TALE OF TWO WOMEN

During my lectures and tours dealing with the Franco-Americans of Manchester, I show photographs of two women. One is seated at her spinning wheel at home. The other is standing between rows of looms in a textile mill. Together, these images evoke certain points about rural life and work in Québec juxtaposed with the urban industrial experience of Québécois immigrants to such places as Manchester. I ask people to pretend that they're of the same woman before and after her migration from Québec to Manchester.

Since most Québécois immigrants came from small cities or from villages, the lady at her spinning wheel represents a typical farming woman whose lifestyle in her homeland differs radically from what she'll face in Manchester. For generations, everyone in her village has known everyone else. With few exceptions, they're devout Catholics whose lives revolve around their faith, large family, the French language and cultural traditions. She and her family feel a strong sense of belonging to a community of like-minded individuals. Though most live modestly, they own their own homes on their own land. They help one another in times of need, from childbirth, illness and death to barn raising and animal slaughtering.

The farm wife labors at home, indoors and in the field, the latter with her husband and children. She works on her own terms at her own pace, makes her own hours—often from before sunrise to long after sunset—and rests whenever she feels the need. Her environment is relatively quiet, and the air is pure.

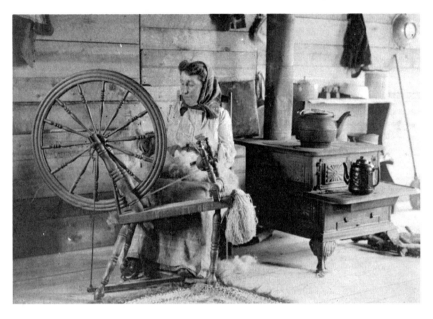

Lucie Laverdure, the photographer's mother-in-law, spinning domestic wool in the summer kitchen of her family's farmhouse. Valcourt d'Ely, Québec, circa 1908. *Photo by Ulric Bourgeois.*

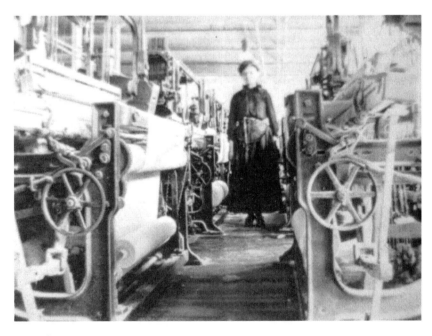

Anna-Émilia Saint-Denis Boucher, weaver, Amoskeag Manufacturing Company, circa 1910. *Courtesy of her daughter, Jeannette Pepin.*

Vivre la Différence

Most immigrants came from villages that, in many ways, contrasted with New England's industrial cities such as Manchester. Fulford, Québec, circa 1908. *Photo by Ulric Bourgeois.*

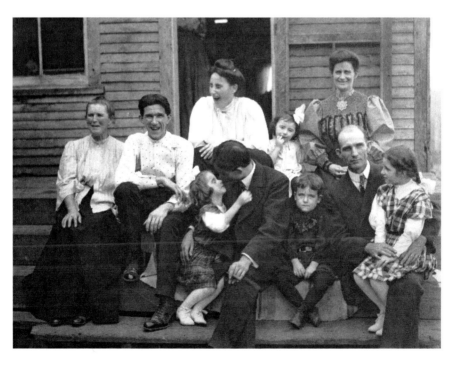

Members of the Bourgeois family relaxing at home in their factory-made Sunday-best clothing. Fulford, Québec, circa 1908. *Photo by Ulric Bourgeois.*

Spinning is but one of her many steps in the making of clothing. She obtains wool from her sheep or harvests flax grown on her family's land. With her tools and other domestic apparatus, she transforms these raw materials into shirts, blouses, pants, dresses, sweaters or whatever her family needs. When finished, she views these creations with a feeling of accomplishment and pride, which, in turn, gives her a sense of identity with her work. Although she works hard, knowing that it benefits her family gives her satisfaction.

While some might see this picture as idyllic, the woman's life has its drawbacks. Despite all the time and effort she and her family put into their chores, crops can fail, animals can become ill and die and severe weather can destroy crops and animals, not to mention dwellings. Moreover, unless one or more family members work elsewhere as a hired hand, blacksmith or midwife, little or no money comes in.

Thus, the woman and her family decide to abandon the rural agricultural atmosphere of their village in favor of a more profitable, secure life in the urban industrial setting that reigns in their adopted home, Manchester.

Dwarfed by looms that surround her, the woman now inspires a new set of feelings and circumstances. We imagine what culture shock she and her family have experienced since their arrival in this busy, strange American

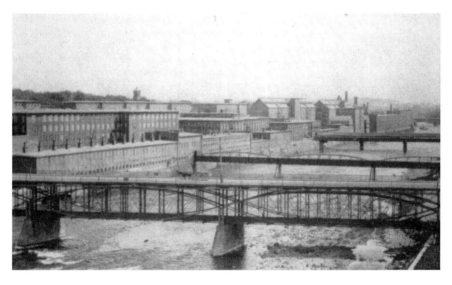

Looking south along the Merrimack River toward the McGregor (Bridge Street) Bridge and mills of the Amoskeag Manufacturing Company, 1892. *Photo by Art Work of Manchester.*

Vivre la Différence

city. Having left behind the tranquility of their Québécois village, her family got off the train at Manchester's Union Station where, nearby, in addition to paving-stoned streets filled with noisy traffic—perhaps even a few of those new horseless carriages—they see row upon row of gargantuan red brick buildings that stretch for a mile along the banks of the Merrimack River. These are the textile mills of the Amoskeag Manufacturing Company.

Instead of owning their own home, her large family rents a tiny apartment in one of the many crowded tenements in the neighborhood called Notre-Dame. Perhaps members of their extended family, or friends from back home, live nearby. If not, they at least have, as neighbors, immigrants such as themselves who speak French and attend Mass at Sainte-Marie's Church.

Regarding her daily routine, the woman no longer has control. A mill bell summons her to work by 6:00 a.m. There, she labors until 6:00 p.m., with only a brief pause for the noon meal, which one of her children brings her from home, still warm, in a dinner pail. If she's tired, she must ask permission for a break, a privilege left up to the discretion of her superiors. Most of them speak only English—that is, unless she's fortunate enough to work for a second hand—a minor boss—who speaks French. This is the company's way of controlling the employees by placing them under the direction of one of their countrymen. Most likely, she works in a weave room with other French speakers, though she might just as easily end up with immigrants who represent a mixture of languages, faiths and customs who must work together for the good of the company. Sometimes there is harmony, sometimes not.

L'École Hévey, Sainte-Marie's all-boys' parochial school and houses along Cartier and Wayne Streets, seen from the church roof, 1930. *Photo by Durette.*

Franco-American Life and Culture in Manchester, New Hampshire

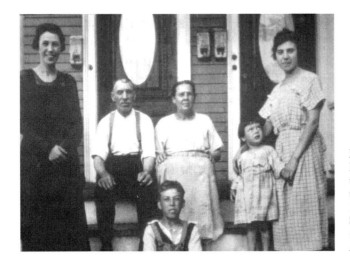

Members of the Beaulieu family on the steps of their three-family house, 102 Kearsarge Street, circa 1925. *Courtesy of Doris Lizotte.*

Unlike the quiet ambiance of the family farm, she endures an incredibly noisy weave room as the nonstop din of hundreds of looms simultaneously going click-clack-click-clack-click-clack-click-clack drowns all other sounds, makes the entire mill building tremble and even haunts her dreams at night. This inevitably results in premature hearing loss. And forget about breathing fresh air, because a textile mill requires closed-in heat and humidity, where she inhales cotton dust that can lead to a variety of respiratory ailments.

All day long, she works at that one repetitive operation. She weaves cotton owned by the company, as are the looms on which she helps produce not finished clothing but mere cloth that also belongs to the company. Consequently, at the end of her workday, she has nothing tangible to bring home to show her family the fruits of her labor. Her relationship with her work and its end product has drastically changed from what it was in Québec.

But unlike on the farm, where her hard work might not have paid off, here in the mill she's guaranteed a regular wage, however meager. She realizes that her labor earns the company a sizeable profit in comparison to what she receives in her pay envelope. While she might feel exploited, she's also grateful for the security that a steady income offers. Consequently, she and her family will remain in Manchester.

Thanks to the photographs of these two ladies, we have a clearer idea of life on both sides of the Canadian-U.S. border and why so many thousands of Québécois left their farms to settle in Manchester.

FATHER OF THE FRANCO-AMERICAN PRESS

A couple strolls into Lafayette Park on Manchester's West Side. Midway through, they pause as the woman recalls a childhood memory.

"You see that statue?"

"What about it?"

"In the 1950s, when I lived down the hill in the Flat Iron district, this park was our playground. Kids made up a story about that statue. If you climbed and looked into the palm of the man's right hand, there was a button. If you pushed it, the statue would drop and take you down to hell. A lot of us believed it. Only the really brave kids dared go near the statue."

If, indeed, the statue could move, it would go upward, as it represents one of the most illustrious figures in the history of French-language journalism in the United States, Ferdinand Gagnon.

A native of Saint-Hyacinthe, Québec, where his father, a wheelwright, had his shop, Ferdinand Gagnon was born on June 8, 1849, one among twelve children—nine of whom died in infancy—of Jean-Baptiste Gagnon and Élisabeth Marchessault. Of above-average intelligence, Gagnon, at age ten, enrolled at the Séminaire de Saint-Hyacinthe, where he pursued a classical course. Upon graduating at sixteen, he began working as a clerk in the law firm of Letendre and Mercier of Saint-Hyacinthe.

Filled with political fervor, he made speeches favoring Québec's Parti Libéral, thus irritating one of his employers. Honoré Mercier, a conservative, chided Gagnon for mingling with the *rabble*—liberals. Ironically, in

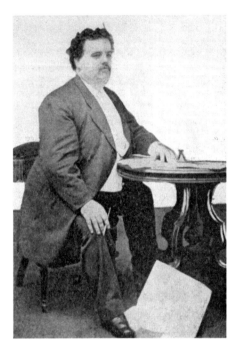

Ferdinand Gagnon in 1871.

subsequent years, Mercier joined his adversaries' party, assumed its leadership and eventually became prime minister of Québec, while Gagnon gradually evolved into an arch conservative.

In January 1868, Gagnon visited his parents, who had migrated to Concord, New Hampshire. There, as a clerk for the law firm of Marshall and Chase, he acquainted himself with the U.S. legal system. In addition, as secretary of Concord's Société Saint-Jean-Baptiste—one of many similar French-Canadian mutual benefit societies with social and political overtones—he advocated for Canadian independence. By October of that same year, he had moved to Manchester.

At nineteen, Gagnon had no definitive plan, no precise philosophy and no vision of his future path. Yet he burned with desire to share his nascent ideas with his fellow Québécois immigrants. His primary concerns revolved around their collective fate. Although at this time most people viewed the wave of migration from Québec to New England as temporary, Gagnon foresaw the permanence and eventual rise of French-Canadian communities throughout the region.

While preparing for his lifelong vocation, journalism, Gagnon substitute taught French during the day and more regularly in night school. On February 25, 1869, with the financial backing of Doctor Adolphe Tremblay, local physician and founding member of Manchester's Société Saint-Jean-Baptiste, Gagnon launched *La Voix du Peuple*, the city's and state's first French-language newspaper.

The four-page weekly sold for the relatively high price of $0.05 per issue or $2.25 per year. As often occurred with early French-language newspapers in the United States, *La Voix du Peuple* encountered financial difficulties and ceased publication on September 15, 1869. However brief, it laid the

Vivre la Différence

La Voix du Peuple, Manchester's first French-language newspaper, 1869.

groundwork for nearly forty French-language newspapers that appeared in Manchester between 1878 and 1971, including a daily, *L'Avenir National* (1894–1949), and its weekly successor, *L'Action* (1950–71).

In autumn 1869, Gagnon moved to Worcester, Massachusetts, where, on October 16, he married Malvina Lalime, who bore him ten children between 1871 and 1882. She often accompanied him on the piano while he, possessing a powerful voice, sang selections from various operas. Because Gagnon could not feed his ever-growing family solely on his newspaper editor's wages, he formed a partnership with his brother-in-law, Alfred Lalime, to produce various insignia for clubs and societies.

Despite more short-lived journalistic attempts, Gagnon's career began taking shape. Conscious of the power of the press, he used it to express his views or to make suggestions to his readers. As a brilliant writer and orator, he eventually won respect in Francophone circles as far away as Canada and the American Midwest. Moreover, Gagnon dreamed of creating a press that would help his compatriots form a collective, distinct identity within American society while also serving as their religious, linguistic, cultural and political voice.

On Gagnon's fifth wedding anniversary, October 16, 1874, his dream began coming true with the publication of the first issue of *Le Travailleur* (*The Laborer*) of Worcester, his—not to mention *the*—most successful newspaper in the pioneer era of the Franco-American press. Under the slogan "*Fais ce que dois*" (Do what must be done), Gagnon dealt with issues relevant to the everyday life and future of his readers.

Besides news, Gagnon inspired the creation of newspapers devoted to political organizing, education, literary creation, etc. Here, *Le Canado-Américain* attracts new immigrants to Manchester, 1913.

Through *Le Travailleur* he acquainted his fellow immigrants from different areas with one another. He spoke of mutual aid, political awareness, faith in God and more. To the Québécois back home, many of whom treated emigrants as prodigal children who had forsaken their country for material pleasures, Gagnon extolled the virtues of French-Canadian life in the United States.

Two issues for which Gagnon is best remembered are repatriation and naturalization. As a repatriation agent for the Québécois government, Gagnon urged all French Canadians who felt alienated in the United States or who had become disillusioned to return to Québec. To set an example, he repatriated his parents, though he and his own family remained in Worcester. Gagnon also collaborated in founding a town, La Patrie (The Homeland), just north of the Pittsburg, New Hampshire/Chartierville, Québec border, where Canadians living in the United States could obtain land for free merely by resettling there. Meanwhile, to those who planned to remain in this country but retain their Canadian citizenship, thereby denying themselves the benefits and rights of U.S. citizenship, Gagnon recommended naturalization, as well as the formation of naturalization clubs throughout the United States.

By pushing for repatriation and naturalization simultaneously, Gagnon drew both praise and condemnation. His fiercest adversary was Honoré Beaugrand, editor of *La République* of Fall River, Massachusetts, a staunch supporter of repatriation who eventually returned to Québec and assumed

the mayoralty of Montréal. What began as a mere difference of opinion subsequently escalated into a vicious quarrel. During the holiday season of 1875, in response to editorial assaults leveled against him by Beaugrand, Gagnon wrote, "Mr. Beaugrand preaches religion in his newspaper, but when with his friends he boasts of being a Freemason; he mocks sacred objects and does not have his children baptized, all the while pretending, before his compatriots whom he exploits, to be a man of principle. We are through with him: let him continue to throw mud at us with his Freemason's trowel, we'll have nothing to say to him."

The following week, Beaugrand retorted: "God made you an invalid. Mother Nature gave you the gift of a physique that could, if needed, be used for target practice by an infantry regiment at 1,000 meters. When you appear in the streets of Worcester, children collapse, grandmothers seize their prayer beads, and old wives cry out: 'It's Bogey Man Gagnon!'"

What makes Beaugrand's comments so biting is that, to a certain degree, they were true. Although not an invalid, Gagnon, who measured five feet, nine inches, had one leg shorter than the other, which resulted in his needing a cane. According to varying accounts, he weighed at least 275 and perhaps even up to 340 pounds. Nevertheless, his enormous strength enabled him, weekly, to fill a large mail sack with freshly printed copies of *Le Travailleur*, which he carried over his shoulder to the post office.

The polemic between Gagnon and Beaugrand intensified to the point where the latter challenged the former to a duel. Due to his family responsibilities, Gagnon declined. Yet what Beaugrand never had the chance to do in 1875, Gagnon's large size did, shortly before his thirty-seventh birthday. Afflicted with Bright's disease, a kidney ailment, Gagnon saw himself at death's door. In the March 12, 1886 edition of *Le Travailleur*, he published his farewell message. Entitled "Nos adieux," this brief but poignant bit of prose ends in the following fashion: "We ask forgiveness of all those whom we might have offended, just as we pardon those among our enemies who might have done us harm. May all live in peace, in good fortune, and in contentment. Adieu! Adieu! Adieu…"

Ferdinand Gagnon died on April 15, 1886, and lies in Worcester's Notre-Dame Cemetery. *Le Travailleur* outlived him by six years.

During his short but fruitful career, Gagnon sowed the seeds of a press that flourished well into the twentieth century. That was his legacy to his people, who have called him "Father of the Franco-American Press."

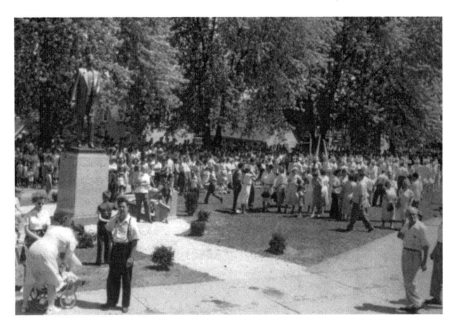

Dedication of the Ferdinand Gagnon monument, Lafayette Park, June 1949.

To honor Gagnon's memory, the late Wilfrid Beaulieu, longtime proprietor of Manchester's Lafayette Press, founded a newspaper in Worcester called *Le Travailleur*. Printed in Manchester, it was published from 1931 until its owner-editor's death in 1979.

In 1940, Josaphat Benoit, later mayor of Manchester, published a book entitled *Ferdinand Gagnon: biographie, éloge funèbre, pages choisies* (*Ferdinand Gagnon: Biography, Eulogy, Selected Pages*), a revised version of a work attributed to Québécois historian Benjamin Sulte that appeared shortly after Gagnon's death.

In June 1949, the centennial of Gagnon's birth, hundreds of Franco-Americans and representatives from Québec and France gathered in Lafayette Park to dedicate a monument in his honor. Commissioned by Gagnon's niece, Malvina Gagnon-Martineau of Los Angeles, and executed by Boston sculptor Joseph A. Coletti, the nine-foot statue depicts Gagnon as considerably thinner but nonetheless proud and determined.

A translation of the inscription on the base reads: "Ferdinand Gagnon 1849–1886. Journalist, orator, founder of the Franco-American press. Published in 1869 *La Voix du Peuple*, first French newspaper in Manchester, N.H. and *Le Travailleur*, in Worcester, Mass., from 1874 to 1886."

ONE IMMIGRANT'S VIEW

Through the Lens of Ulric Bourgeois

The French novelist Marcel Proust believed that art provides a means of preserving vivid impressions of individual moments that would otherwise fade with the passage of time. In his serial novel *À la recherche du temps perdu*—literally, "in search of lost time" but published as *Remembrance of Things Past*—he delved into the worlds of painting, music and, of course, writing. If Proust's notion were applied to photography and if a picture is worth a thousand words, the photographic legacy of Ulric Bourgeois could inspire the writing of countless volumes on the day-to-day life of a bygone era.

The scene is typical. In a local museum, an elderly man examines a Bourgeois photograph depicting the artist's father building a baby's coffin. This experience unleashes the man's memories of watching his own grandfather work. Suddenly, a young woman approaches and comments on the sadness of Bourgeois' image, and a conversation ensues. Her recollections begin to surface, and before long, the two have recaptured moments from their respective pasts.

Whether or not he realized it while creating this visual record of his father, Bourgeois confirmed Proust's theory, as his work indeed motivates us to search for our own lost time. My personal fascination with Bourgeois' work dates back to my first visit with his eldest daughter, Antoinette, in August 1977. At the time, I was working with Gary Samson, director of the Manchester Visual History Project, to uncover vintage photographs not already included in the Manchester Historic Association's archives. For five hours, Antoinette kept me in awe as she reminisced, in French, about her father's adventures

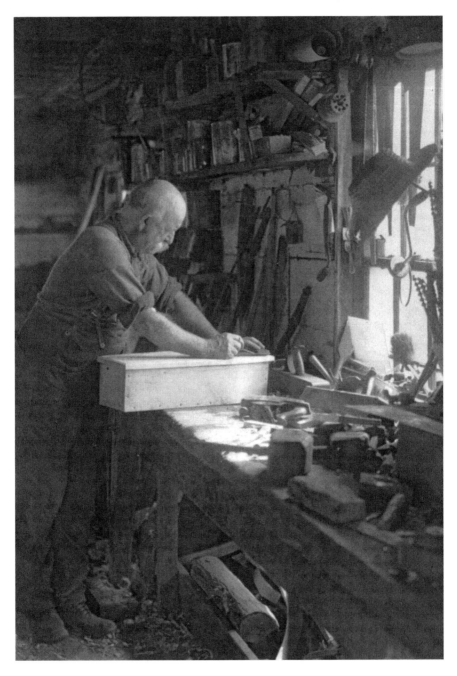

Farmer, blacksmith and all-around craftsman Lucien Bourgeois, the photographer's father, builds a baby's coffin in his home workshop. Fulford, Québec, circa 1908. *Photo by Ulric Bourgeois.*

Vivre la Différence

in photography while showing me hundreds of his images. I couldn't wait to tell Gary about these newfound treasures.

The son of blacksmith Lucien Bourgeois and his wife, Delphine Bissonnette, Ulric was born on September 17, 1874, by the banks of the Rivière Yamaska in the Loyalist village of Fulford, in Québec's Eastern Townships. Raised in a Francophone family surrounded by Anglophone neighbors, Bourgeois possessed a double advantage: his knowledge of two languages coupled with gifted eyes that displayed sensitivity toward life's aesthetically pleasing aspects.

At age eleven, Ulric received a crude but functional box camera that a local physician, Doctor Louis Pagé, had made in 1856. For a few years, he took pictures in and around Fulford. Subsequently, he perfected his craft by obtaining employment at the Éthier Studio in Waterloo, Québec. There, he met his future wife, Lucie Laverdure of Valcourt, Québec.

At the close of the nineteenth century, the newlyweds migrated to Manchester, where one of Ulric's eight siblings—his brother Stanislas—had settled. Ulric's bilingualism and his photographic talent resulted in his rapid integration into mainstream Manchester. Unlike many immigrants who labored for years in textile mills or shoe factories, Ulric spent only a brief time working for the Amoskeag Manufacturing Company. While the 1902 *Manchester Directory* listed him as an inspector—most likely of cloth—the 1903 edition described him as a clerk at 809 Elm Street, the John B. Varick Company's department store.

A man of initiative, Ulric convinced his superiors to create a photographic department and studio with himself in charge. To achieve success, he offered a varied selection: portraiture, advertising, illustrations for books and magazines, postcards, architectural views, industrial photography, X-ray processing and postmortem photographs for the police or coroner.

Antoinette Bourgeois had colorful recollections of her father, one dating back to 1907. "My father came home with a box under his arm. It was in a black bag. We had one of those old-style sofas and he put the box underneath. Being a five-year-old, I was curious about what was in that box. The next day, my father told me, 'You're going to have your picture taken today.' So, he sat me at an angle and my arm was on the table. Then, he brought that thing out of the box and put it on the table. He told me: 'Touch him, he won't bite you.' It was a skull! That skull must have been very young when it died because it had all its teeth. My father said the body had been given

to science and he was asked to go down to the Harvard Medical School to take pictures of the dissection. That's how we got it. But I was afraid of it. I didn't want to touch it."

Postmortem photography had its darker moments. Just as emergency workers remain on call, so did Ulric, in case the coroner needed him. "He'd come home when he had these cases and he wouldn't eat. My mother wouldn't question him. She knew. She'd say, 'Don't bother your father.' But it was part of his job. Somebody had to do it."

Ulric's other duties involved more pleasant circumstances. He had an amazing rapport with children and animals, seeming to possess magical powers over them. Besides Antoinette, Ulric and Lucie had three younger children: Lucienne, who became a well-known piano teacher and concert master; Irène; and Albert. Ulric often used them and their pets as models in advertisements.

Ulric once created an ad that he wished had gone unnoticed. To feature the latest in swimwear, he took candid shots of people on the beach at Nutt's

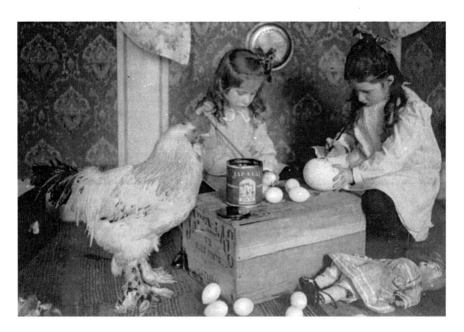

Varick's ad featuring Dick, the family's rooster, watching Bourgeois' daughters Irène and Antoinette paint Easter eggs with JAP-A-LAC Japanese lacquer, circa 1910. *Photo by Ulric Bourgeois*.

Vivre la Différence

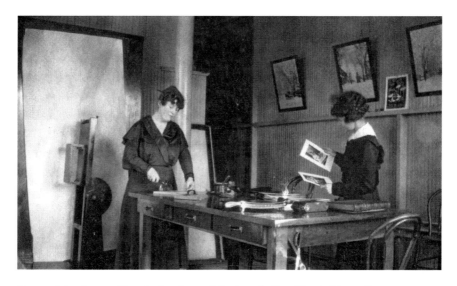

Bourgeois' assistants, Blanche Lussier and Corinne LeBoutillier, in his studio, summer 1918. Corinne's father, Jean-Georges LeBoutillier, was *L'Avenir National*'s editor. *Photo by Ulric Bourgeois.*

Pond. When the ad appeared, a woman recognized one of the bathers—her husband—in the company of another woman. Ulric's routine assignment transformed itself into a marital nightmare that resulted in divorce.

Occasionally, Ulric photographed important events, including the signing of the Treaty of Portsmouth in 1905, which ended the Russo-Japanese War, and the appearance of Halley's Comet in 1910.

Antoinette gained insight into her artist-father's profession by assisting him during her school vacations and for five years following her graduation in 1917 from L'Académie Notre-Dame in Saint-Augustin Parish. "My job was photo finishing. I'd retouch, cut, trim and dry the pictures, and then emboss them."

Most often, Ulric used a five- by seven-inch Kodak view camera equipped with a Gundlach lens. His portraiture style differed from that of his contemporaries, as he preferred photographing people in their habitual surroundings rather than in his studio. He created works of art that reflected a meaningful relationship between his subjects and their environment and also between themselves and himself. Unlike the stiff poses typical of his era, people in Ulric's photographs appear natural and relaxed.

At Varick's, Antoinette became acquainted with her father's clients. Her most unforgettable was Reverend Henri Beaudé, a well-known author in his

day who wrote in French, using the pen name "Henri d'Arles." He served as curate at Saint Anthony Parish, as assistant chaplain of L'Association Canado-Américaine (ACA) and as chaplain at the all-girls' Académie Villa Augustina in Goffstown. "He was a very kind and gentle man, very handsome too. He was also very good with the poor. He was a proud man, too. He had very expensive tastes: silk stockings and things like that. He always carried a cane even though he didn't need it. Once, when he'd asked my father to go over to Saint-Antoine's rectory to take his picture, he put on this long cape and sat at his desk. You can see in that picture just how proud he was to be an author. My father printed a dozen of those pictures and then he told me to make up a special package. I had to tie the package with string and make a nice bow, otherwise, my father said, Henri d'Arles wouldn't accept it. It had to be wrapped *his* way. So finally, he came in, he examined his package,

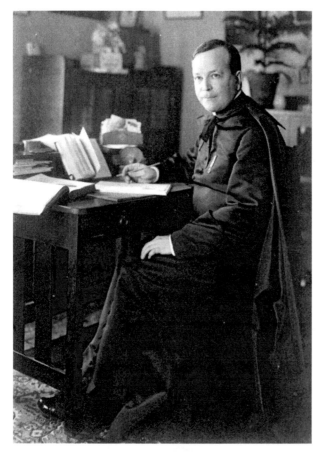

Author Henri d'Arles in Saint-Antoine-de-Padoue rectory, Manchester, circa 1915. In 1922, his three-volume history, *Acadie*, was crowned by L'Académie Française in Paris. *Photo by Ulric Bourgeois.*

Vivre la Différence

really inspected it. Once he was satisfied, he stuck one finger in each loop of the bow, picked up his cane with his other hand, said 'good day,' and he was gone. That was Henri d'Arles."

Over time, Bourgeois earned a reputation as a highly skilled commercial photographer. However, his contribution to the worlds of art and history rests with images he created apart from his commercial work, labors of love that few people knew existed. These are the chefs-d'oeuvre through which Bourgeois lives on. One series depicts life and work among Québécois craftsmen and farmers in the early twentieth century, featuring his family members. When combined with his Manchester family photographs, they form an important historical archive documenting the immigrant experience, as seen by one who lived through it.

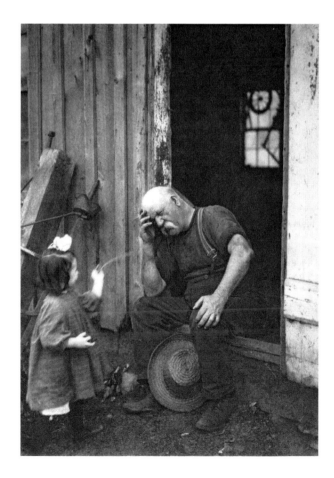

Lucienne Bourgeois, the photographer's daughter, teases her grandfather, Lucien, in the entrance to his workshop. Fulford, Québec, circa 1908.
Photo by Ulric Bourgeois.

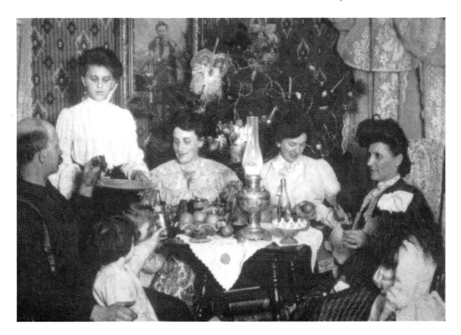

The Bourgeois home at Christmastime, Manchester, circa 1905. *Photo by Ulric Bourgeois.*

One poignant series features Charlie Lambert, "the hermit of Mosquito Pond"—now Crystal Lake—who lived "à la Henry David Thoreau" in the woods outside of Manchester from the 1840s until two years before his death at age ninety-one in 1914. Antoinette reminisced about having met Lambert face to face when she was five. "I can still see him standing there in the doorway to the kitchen. To me, he looked so big and tall. His skin was all scorched and cracked from having lived outside under the sun for so long. And filthy! Did he ever stink! I was so afraid of him that I hid behind my mother, but they made me shake his hand anyway. But he was a nice old man, very gentle. He was a real character."

In the early 1930s, Ulric left Varick's and established his own studio. There he remained until his wife's death in 1950. He retired at age eighty-three in 1957.

Throughout his career, Ulric cultivated another talent, wood sculpture, which he did full time upon retiring. He often used his photographs as models for bas-reliefs. In 1958, the Manchester Historic Association exhibited his sculptures, including one of Charlie Lambert reclining on his crude bed.

Vivre la Différence

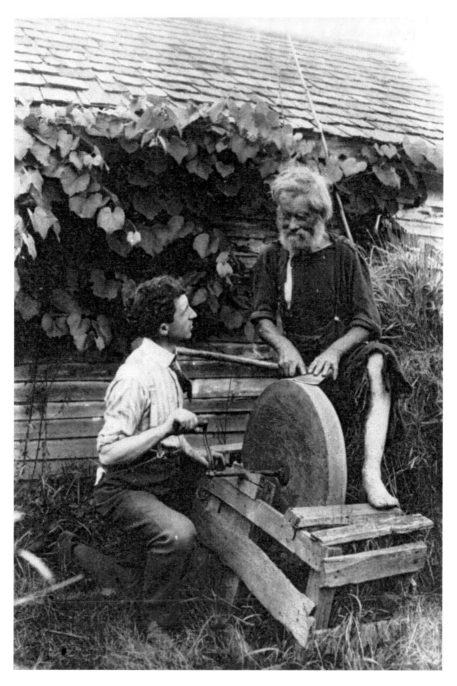

Ulric Bourgeois assists Charlie Lambert, the hermit, in sharpening an axe by Lambert's cabin near Mosquito Pond, circa 1905. *Photo by Ulric Bourgeois, self-portrait.*

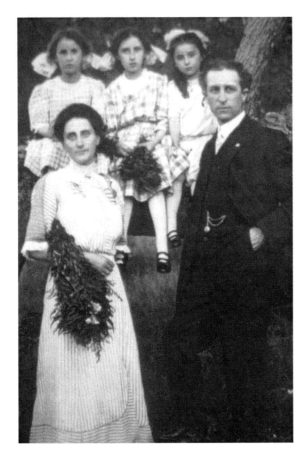

Lucie and Ulric Bourgeois with their daughters Irène, Antoinette and Lucienne, Manchester, circa 1912. *Photo by Ulric Bourgeois, self-portrait.*

Ulric Bourgeois died on September 7, 1963, ten days before his eighty-ninth birthday. Since 1977, when Antoinette began sharing her father's private collection with Gary Samson and me, Bourgeois' photographs have toured New England, Québec and France. They have also appeared in newspapers, magazines, books and educational films.

Antoinette spent her final years being reenergized through her father's legacy. "My father loved life, he loved people, art, nature, he loved everything. And I think it shows in his pictures. If the walls of this house could talk, they'd tell stories of a family full of love, humor, good times and faith in God. Now, everything is silent because they're all gone except for me, but the memories are still here and that's what keeps me alive. My only regret is that my father isn't here to see how things have turned out with his pictures. But I'm sure he knows and I'm sure he's proud."

FRENCH V. IRISH

Why the Beef?

Not long ago, that was a thorny question. Nowadays, except for die-hard Manchesterites of French-Canadian or Irish descent, it's a matter of historical curiosity. Average members of both groups have become so Americanized that they've forgotten the issues over which our respective ancestors once fought. Consequently, they sometimes request my opinion. My usual response: "Do you have a couple of hours?" People want to know what started the conflict and who's to blame. I reply that it's merely an unfortunate collision of two cultures over how each believed that certain aspects of human activity—in this case, at work and in church—ought to have been conducted. As expected, either group acted in its own interest, often to the detriment of the other. Both shared enough Catholic guilt so that neither came out spotless.

Considering their traits in common, our respective ancestors should have gotten along. Both groups were Roman Catholics with large families. Both lived in poverty on farms in Ireland or Québec. Both were subjugated and oppressed by the English and, later, encountered prejudice at the hands of New England Yankees. Both settled in cities such as Manchester, largely as members of the working class. Moreover, many Franco-Americans are of Breton descent. Bretagne (Brittany) in extreme western France is populated by Celtic people whose traditional language and culture resemble those of Ireland.

Through research, discussions and reflection, I've formulated my own theories. While some might take exception, I believe that the roots of past conflicts between our two groups lie more deeply than the usual suspicions

aroused by geographical, linguistic and cultural differences. Certain events in our respective histories shaped the thoughts and behaviors of both groups to the point where, upon migrating to the same areas, they discovered that their ideas clashed.

First, the Irish. For centuries, as Catholics in the Protestant-dominated British Isles, they suffered untold violence, theft of their lands, poverty, starvation and the near-complete eradication of their language. Some migrated to the New World during the colonial era, settling either among English Catholics in Maryland or most likely in Canada, where they blended into French Catholic society. Interestingly, a few descendants of these latter families eventually came to Manchester as French-speaking Québécois. Among them were the Fitzpatricks and the Farleys. The Fitzpatricks owned a printing firm. So integrated were they into Franco-American society that they often printed French-language materials, named one of their sons "Laterrière" Fitzpatrick after a Québécois ancestor and had a daughter, Lucie Fitzpatrick, who taught French at Manchester Central High School. Meanwhile, Irène Farley founded Les Rosiers Missionnaires de Sainte-Thérèse (the Missionary Rosebushes of Saint Teresa), a fundraising organization for the education of Third World seminarians. Her brother, Paul Farley, was a talented organist.

The Industrial Revolution drew Irishmen to the American Northeast, where many dug transportation or power canals. Most Irish Catholics, however, came here in the mid-1840s and subsequently to escape Ireland's potato famine. Although many flocked to Boston or New York, some chose New England's smaller industrial centers such as Manchester, where the burgeoning textile industry needed extra hands. Being farmers now classified as unskilled laborers, they earned meager salaries and endured poor working conditions. But not for long. Eventually, they demanded, fought for and to some extent succeeded in obtaining higher wages and an improved occupational environment.

In Manchester as elsewhere, the Irish became victims of anti-Catholic attacks: vandalism and arson committed against Catholic institutions or assault and even murder of religious and lay Catholics. Many perpetrators of these crimes belonged to the American or Know-Nothing Party—so called because when questioned about their activities, its members replied "I know nothing." Manchester's most infamous anti-Catholic incident occurred on July 4, 1854. A mob assaulted several Irish Catholics and all but destroyed a

Vivre la Différence

dozen of their homes. Afterward, they stoned the windows of Saint Anne's Church, stopping only when John Maynard, a Protestant who lived across Merrimack Street from the church, somehow convinced the mob to disperse. Other crimes include attempted arson at the construction site of the Sisters of Mercy Convent in 1858 and at Saint Anne's Church—ironically, by a mob of drunken firemen in town for the Firemen's Muster of 1859.

In response, the Catholic Church's hierarchy, which in the northeastern United States was overwhelmingly composed of Irish bishops, adopted measures destined to enhance the Church's image as a means of mitigating anti-Catholic sentiment. They hoped Catholics would shed their foreign traits in order to fit into mainstream American society, thus forming a strong, united Catholic Church.

And then, from up north, came a new group of Catholics with a different vision.

To French-Canadian immigrants, the Irish work ethic and Catholic Church policies conflicted with principles they'd developed since having fallen under British rule after the Battle of the Plains of Abraham outside Québec City in 1759. Rather than deport the Québécois and take over their lands as they'd done to the Acadians of eastern Canada in 1755, the conquerors attempted to transform them into loyal British subjects by imposing the English language and Protestantism upon them. The Québécois vehemently resisted by clinging to both French and Catholicism. The two became so intertwined that a new ideology sprang from this marriage of concepts: *la survivance*—cultural survival via language and faith. "*Qui perd sa langue perd sa foi*" (He who loses his language loses his faith) and "*La langue, gardienne de la foi*" (Language, guardian of faith) are mottos that Franco-Americans in Manchester and elsewhere repeated well into the twentieth century. To assure the success of *survivance*, the Québécois, seeing strength in numbers, began to outpopulate the English settlers, a practice known as "*la revanche du berceau*" (the revenge of the cradle).

Unable to convert the Québécois, the English, who now held the country's wealth and power, treated them as second-class citizens. Having settled mostly in Montréal, Québec City and the Eastern Townships, they allowed the majority of Québécois to continue living in rural areas, where farming families recognized an alternate authority: the Catholic Church. Unlike its counterpart in New England, however, the Church in French Canada

ruled less from the diocesan level—bishops being stationed far away in the cities—but more locally, wherein the pastor and a parish council composed of area residents had a certain level of autonomy. Although parishioners had a voice in their village church's finances and other temporal affairs, pastors nevertheless tried controlling people's personal and spiritual lives. They preached in favor of hard work, humility, obedience to authority and accepting one's fate.

Meanwhile, politically speaking, some Québécois harbored desires for Canadian independence or annexation to the United States. Anti-English sentiments came to a head, leading to the Insurrection of 1837–38 in several villages along the Richelieu River. Some eight thousand government soldiers had no difficulty defeating a few hundred Québécois rebels armed mostly with farming tools. This blow—along with poor economic conditions, the lack of land to house everyone and of good soil for crops to feed their large families, not to mention stories of prosperity just across the border—inspired many Québécois to head to New England's industrial centers.

Upon arriving in Manchester, the Québécois accepted whatever jobs offered a steady income. Mill management and other Yankee employers didn't always embrace these French-speaking papists, but they exploited them for their "industrious and docile" work ethic.

By their willingness to work long and hard at menial, low-paying positions, French Canadians incurred the wrath of their fellow Catholics, the Irish, for whom this amounted to taking a backward step in their struggle to improve theirs and all industrial workers' lot. Moreover, some lost their jobs to recruits from French Canada, whom the mills hired at reduced wages.

Naturally, conflicts in varying degrees arose between the two groups. Through contemporary Manchester newspaper accounts whose descriptive style rivals that of crime novels, or through interviews and discussions, I've read and heard it all: name-calling, vandalism to one another's property, snowball- or rock-throwing, fistfights, barroom brawls, beatings of individuals by multiple attackers, street riots and gang wars and even homicide—unintended or willful. People on both sides have told me stories of prejudice, such as parents forbidding their children to play with those of the other group or disowning an adult child for contracting a mixed marriage, thus cutting themselves off from their potential grandchildren. Some preferred that their offspring marry a non-Catholic rather than a Catholic of the opposing ethnic group. Prejudice also extended to politics. As members of the working

class, the Irish gravitated toward the Democratic Party. Many Franco-Americans who might have done likewise became Republicans, as much to avoid associating with the Irish as to appease their Yankee bosses. Only when New York Governor Al Smith, an Irish Catholic and a Democrat, ran for president in 1928 did some Franco-Americans switch parties, just as many more followed suit during the Depression. Friction between French Canadians and the Irish at work and elsewhere extended to the Catholic Church. When Reverend William McDonald founded Saint Anne's in 1848, the Irish and the few French Canadians in town joined the parish. Although born in Ireland, Father McDonald studied at the Grand Séminaire de Montréal. Consequently, he could communicate with his Francophone parishioners, who respected him. Yet, with *survivance* in their hearts, they'd have preferred practicing their faith entirely in French, including hearing sermons by, and confessing their sins to, a French-Canadian priest who shared their mindset and traditions. For these reasons, and due to ethnic tension among parishioners, French Canadians petitioned for a separate parish. Consequently, in 1871, Reverend Joseph-Augustin Chevalier came to Manchester to found Saint-Augustin, the first of eight Franco-American parishes created between 1871 and 1934.

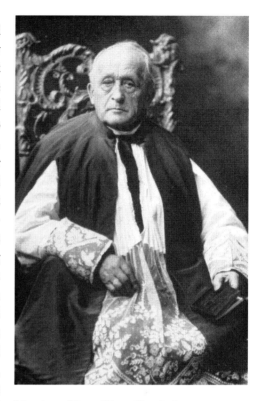

Monsignor Pierre Hévey. *Photo by Durette.*

During the late nineteenth and early twentieth centuries, French-Irish relations within the realm of Catholic Church politics in Manchester remained relatively peaceful compared to events elsewhere in New England. Here and there, certain Irish bishops attempted to acculturate French-Canadian immigrants and their Franco-American descendants by forbidding

or limiting the creation of Franco-American parishes or by naming Irish pastoral and teaching clergy to serve existing Franco-American churches and parochial schools. Accustomed to the Québécois system of control at the parochial rather than at the diocesan level, Franco-Americans protested these measures, causing further tension between both groups.

Under Bishops Denis Bradley (1884–1903) and John Delaney (1904–06), Manchester's Franco-Americans had most of their requests granted, with the possible exception of Monsignor Pierre Hévey, second pastor of Sainte-Marie's Parish. After a fire destroyed the first Sainte-Marie's Church in 1890, the pastor envisioned replacing it with a magnificent neo-Gothic brick structure. Behind the scenes, he advocated for the nomination of a Franco-American priest—or, according to oral legend, himself—to succeed Bishop Bradley upon the latter's death. Earlier in 1890, the Vatican had named Monsignor Hévey prothonotary apostolic, an honorary title he'd obtained via the intervention of the Catholic Church hierarchy in Québec rather than through normal channels in the United States. Again, according to oral legend, if he or one of his compatriots were to succeed Bishop Bradley, he would transfer the cathedral—the seat of the bishop—from Saint Joseph's to Sainte-Marie's, which is why he wished to rebuild his church in a grandiose style. Because Bishop Bradley disapproved of Monsignor Hévey's ambitions and tactics, the two struggled until 1898. After years of rallying behind their pastor, Sainte-Marie's parishioners finally witnessed the construction of the upper

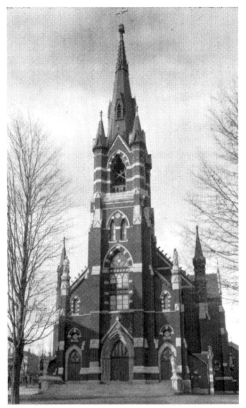

Sainte-Marie's Church, 1930, the parish's semicentennial. It sits directly behind the site of its wooden predecessor on Notre Dame Avenue, originally Beauport Street. *Photo by Durette.*

Vivre la Différence

portion of their church, a mere basement chapel since the fire. It was completed in 1899. In the end, Monsignor Hévey won the dispute over the church's style, but he never became bishop. Curiously, a few early postcards of Sainte-Marie's Church refer to it erroneously as the cathedral.

Manchester's Franco-Americans rejoiced when, in December 1906, Reverend Georges-Albert Guertin, pastor of Saint Anthony's, was named third bishop of Manchester. Several French or French-Canadian bishops had served throughout the Louisiana Territory, out West and even early on in Boston and in Burlington, Vermont. But Father Guertin, a native of Nashua, was the first authentic Franco-American priest to ascend to a bishopric.

One can only speculate as to how Bishop Guertin felt about his new position. Clearly, he knew that Franco-Americans expected him to favor the preservation of their language and culture. He must also have realized that everyone else would scrutinize his every decision. If he leaned too far on the side of his compatriots, it would jeopardize the nomination of future Franco-American bishops. But if he acted otherwise, the Franco-American clergy and faithful would rebel against him as they had against Irish bishops elsewhere.

In 1914, Bishop Guertin named Reverend Thomas J.E. Devoy pastor of Saint-Georges Parish. The choice of a son of Irish immigrants as head of a Franco-American parish must have pleased the Irish clergy. Yet Saint-Georges' parishioners must have been somewhat relieved to learn that their new pastor hailed from Saint-Grégoire-de-Nicolet, Québec. Obviously, he spoke French as well as they did.

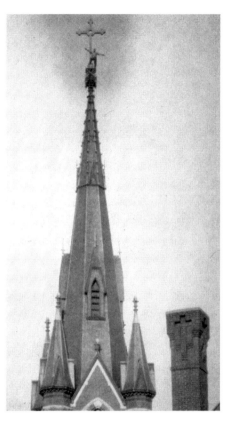

Steeplejack atop the spire of Sainte-Marie's Church, 1930. The cross reaches 224 feet above the ground. *Photo by Durette.*

Franco-American Life and Culture in Manchester, New Hampshire

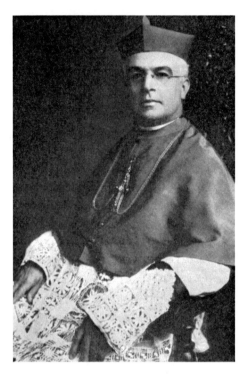

Bishop Georges-Albert Guertin.

After World War I, as anti-German feelings evolved into anti-ethnic sentiments, an Americanization movement swept the nation. Legislators enacted laws limiting the use and teaching of languages, customs and other cultural aspects deemed "foreign." In this climate, a major Catholic Church-related French-Irish conflict finally arose in Manchester. Although it began in Rhode Island in the early 1920s, it had a ripple effect throughout New England and into Québec during most of the decade.

Bishop William Hickey of Providence launched a fundraising campaign to construct diocesan high schools. Accordingly, he assessed each parish in his diocese a given amount from the weekly collection. Certain Franco-Americans believed that these schools would accelerate the acculturation into mainstream American ways of all ethnic students. Besides the detrimental effect the schools would have on the preservation of the French language, protestors argued that several of their parishes already had their own high schools devoted to the formation of perfectly bilingual and bicultural students. Fearing that the new diocesan schools might jeopardize the existence of their Franco-American parochial high schools, many refused to give at weekly collections.

As a defense against Bishop Hickey's proposals, a group of Franco-Americans led by Woonsocket attorney and judge Elphège J. Daignault founded a society, Les Croisés (the Crusaders), whose mouthpiece, *La Sentinelle*, began publication in 1924. In their newspaper, Daignault and his collaborators, known as "Sentinellistes," attacked Bishop Hickey and anyone else whose actions they considered harmful toward the cultural well-being of Franco-Americans.

Vivre la Différence

Because Daignault was also president of L'Association Canado-Américaine in Manchester, that society's officers kept him abreast of the situation in their diocese, which prompted him to write a series of twenty-eight editorials from February 1925 to February 1926. He began by criticizing the diocesan power structure whereby authority belonged exclusively to the bishop, in whose name all Church property was assigned via the system known as "Corporation Sole." Daignault then accused Bishop Guertin of falling under the influence of the Church's Irish hierarchy. For example, he deplored Bishop Guertin's nomination eleven years earlier of Father Devoy to the pastorate of Saint-Georges Parish.

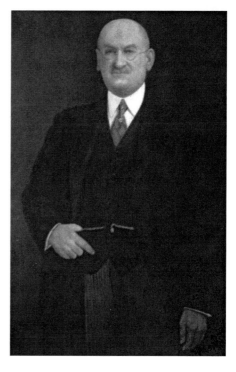

Elphège J. Daignault. *Posthumous oil painting, 1939, by Lorenzo de Nevers.*

He also chided Father Devoy for favoring nuns in his parochial school, L'École Saint-Georges, who were partial toward English rather than French; for speaking only English to students during his school visits but French if he met them with their parents; and for encouraging girls to wear green ribbons to school on Saint Patrick's Day. In short, Daignault felt that Father Devoy used his image as a native of Québec to appease his French-speaking parishioners while baring his Irish soul before their impressionable children.

Although many Franco-Americans shared the Sentinellistes' concerns, they condemned Daignault and his partisans for challenging and ridiculing Church authority in *La Sentinelle*. Franco-Americans throughout New England were divided, pro-Sentinellistes vs. anti-Sentinellistes. In Québec, some bishops and priests openly sided with the Sentinellistes, causing further divisions within North America's Francophone community. Meanwhile, the Church's Irish hierarchy recognized this infighting—that

is, Franco-Americans' tendency to disagree over certain issues—as a collective character flaw. Using a divide-and-conquer tactic, Bishop Hickey and his colleagues exploited this weakness among Franco-Americans. In their dialogue with the Vatican, they portrayed the Sentinellistes as unruly Catholics.

In 1925, as punishment for the ACA's continued support of Daignault as president, Bishop Guertin revoked the society's chaplains, and therefore its Catholic status. By contrast, in early 1926, the bishop rewarded prominent anti-Sentinellistes in his diocese, including Father Devoy, whom he got the Vatican to name domestic prelate with the title of monsignor.

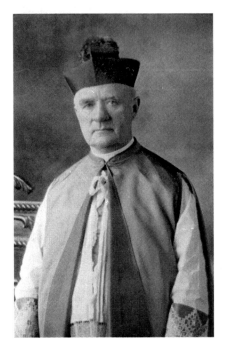

Monsignor Thomas J. E. Devoy.

When Sentinellistes in Rhode Island lost an appeal to the Vatican that their parishes be exempted from Bishop Hickey's fundraising tax, they filed a civil suit against the bishop. On Easter Sunday 1928, the Vatican's official newspaper, *L'Osservatore Romano*, announced the excommunication of the sixty-two Rhode Islanders who had signed the lawsuit. The Vatican also placed *La Sentinelle* on the Church's *Index* of banned publications. The following year, one of Québec's most ardent nationalists, Henri Bourassa, founder and publisher of Montréal's daily *Le Devoir*, stunned Francophones on both sides of the border by condemning the Sentinellistes as "more attached to language than faith, more French than Catholic."

For Franco-Americans, the Sentinellistes' defeat marked a turning point. It further challenged and boosted the fervor of those already committed to preserving their language and culture while creating an even wider gap between themselves and their fellow Catholics, the Irish. For others, it meant an acceleration of their evolution toward mainstream American ways. Meanwhile, the majority fell somewhere in between, more or less

Vivre la Différence

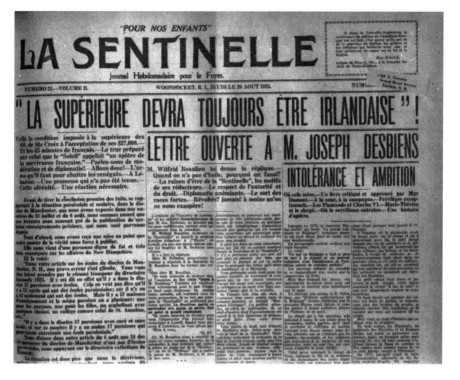

La Sentinelle headline: "The superior [of Saint-Georges High School for Girls] will always have to be Irish." Elphège Daignault attributed this declaration to Father Devoy.

going with the flow. Regardless, as expected, with every new generation, Franco-Americans added more American water to their French wine. With few exceptions, by the time the baby boom generation grew up and started having children, both Franco-American and Irish-American cultures had become so Americanized that conflicts between the two groups had all but disappeared. The only minor clash in recent memory occurred in the 1990s when a few Franco-Americans complained about shamrocks being painted on the pavement on Elm Street. Likewise, a few Irish Americans voiced their opposition to the painting of fleurs-de-lys, also on the city's main thoroughfare.

The passage of time has also shown that the Québécois notion of *survivance*—one cause of tension between French and Irish—could not hold true forever. In their belief that preserving the French language would assure the survival of the Catholic faith, nineteenth-century priests and other advocates of *survivance* warned the Québécois masses to remain in their

homeland and reject the temptation to migrate to that Protestant republic to the south, where they would surely become anglicized and eventually leave the Catholic Church. Ironically, in the wake of Québec's Révolution Tranquille of the 1960s, which strengthened people's ties to the French language while secularizing Québécois society, it is the descendants of those who stayed home who have now drifted away from their Catholic roots. Meanwhile, in Manchester and elsewhere, many Franco-Americans have lost the French language, but a significant number of them are nevertheless practicing Catholics.

For me personally, the French-Irish question had more of an effect than I realized when I was growing up. Only as an adult did I learn how profoundly my family history and my upbringing had influenced my thinking.

As a child living in a homogenized middle-class East-Side neighborhood, I had friends who were Franco-American, Irish American and from other backgrounds. At Saint George School, all my friends were Franco-American—obviously—as was the atmosphere, especially when Reverend Adrien Verrette, a champion of the French language and a Sentinelliste in his days as a young rebellious curate under Father Devoy, became pastor in May of my third grade. I witnessed a limited amount of French-Irish conflict among children during my grammar school years. In winter, I remember a few incidents of kids from our school and from our Anglo-Catholic neighbor, Saint Joseph's School, name-calling and throwing snowballs at one another across Bridge Street. But was it ethnically motivated or simply school rivalry? I do recall, clearly, adults of either group criticizing members of the opposite group. Whenever I asked why, I got the same unsatisfactory answer: "Because they're Irish" or "Because they're French."

During my freshman year at Assumption Prep in Worcester, whose roots were French from France, I saw no conflict based on ethnicity. There, name-calling and teasing ran along geographical lines, either regional or rural vs. urban. But back in Manchester, where I completed my secondary education at Bishop Bradley High School, an all-male diocesan institution of mixed ethnic backgrounds, I witnessed some degree of tension. Those who'd attended Franco-American grammar schools, especially West Siders, were singled out as the butt of ethnic jokes, not only by students of Irish descent but from all cultures—even

Vivre la Différence

Franco-Americans who'd studied at Anglo-Catholic or public grammar schools. Although a minority of these encounters got nasty—today, it would qualify as bullying—some of it was in jest, as Franco-Americans gave it right back to them. In fact, some of my best friends were Irish. Still, I often wondered what lay at the root of our rivalry.

As an adult, I learned much about my family history. Granted, I knew that my maternal grandfather, Adolphe Robert, had served as ACA president and that he was a staunch advocate of all things Franco-American. But it was only a decade after his death that, as ACA librarian, I discovered books and articles—including some written by my grandfather—about the French-Irish conflict and the role he had played in it. As ACA secretary general, he had supported Elphège Daignault during the Sentinelliste crisis.

Although Daignault and his fellow Rhode Islanders all made public reparation and were eventually reinstated into the Catholic Church, the ACA continued to function without its chaplains for as long as he remained president. Even Bishop Guertin's successor, Bishop John Peterson, who was of Swedish descent, refused to restore the ACA's chaplains. As a result, in 1936, my grandfather reluctantly ran against Daignault, who, at the last minute, withdrew his candidacy. With my grandfather as president, Bishop Peterson restored the ACA's chaplains.

I also grew up knowing that my mother, Madeleine Robert, had attended L'École Saint-Georges. Yet it was only when I read Daignault's editorials about Father Devoy that I put two and two together. When I questioned my mother, she recalled the latter's having favored nuns and students who leaned more toward the English language, as well as her father's having forbidden her to wear a green hair ribbon to school on Saint Patrick's Day. For a time, the family even went to Mass at Saint-Augustin's, where the atmosphere was more French.

Needless to say, I now understood why my parents raised my sister Louise and me the way they did: speaking only French to us as toddlers, while letting us learn English by playing with children in the neighborhood; sending us to a Franco-American parochial school; and insisting that we speak only French in the presence of all relatives who either knew no English or favored French. All of that is called *nurture*. But there also exists the *nature* side of family history: heredity.

Long after my maternal grandfather's death in 1966, a distant cousin from Québec did a Robert family genealogy that included maternal lines,

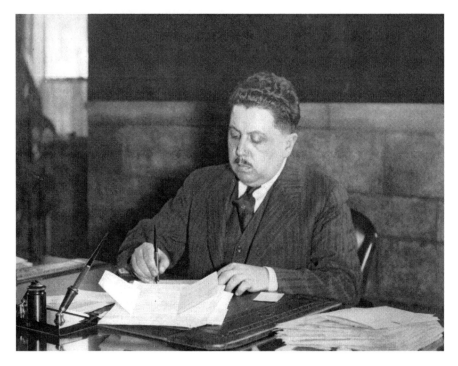

Adolphe Robert, then ACA secretary general, at his desk in the society's newly renovated building, 52 Concord Street, early 1930s.

something my grandfather, in his own strictly paternal study, *Louis Robert et ses descendants* (1943), had ignored or purposely left out. Our cousin's version contained information that would surely have surprised—or, dare I say, perhaps embarrassed—my grandfather. He had a great-great-grandmother whose given name was Marie-Charlotte. Her father's name was Jacques-Philippe. His father was called Antoine. All very French-sounding names. But all three descended from a man called John and a woman called Mary. To be more precise, John Farley and Mary Cary. They came to Québec City at some unknown date but early enough for their son, Antoine, to have married a Québécoise, Marie-Anne Basquin, in 1710. John and Mary had come from Galway, Ireland.

In conclusion, to the French v. Irish question, I have but one word to add: amen.

BEFORE *PEYTON PLACE*

In Search of the Real Grace Metalious

Published in 1956, *Peyton Place* shocked and offended some of its readers and, typically, its non-readers by its media-manufactured image as a violent and sexually explicit novel that, for its day, ventured beyond the bounds of decency. To add to the drama, this story of murder, suicide, rape and incest had flowed not from the pen of a male writer of racy pulp fiction but from the mind of a housewife and mother from Gilmanton, New Hampshire, who dared defy her era's feminine conventions by wearing plaid flannel shirts, jeans and sneakers, not to mention by smoking, swearing and drinking.

Critics dismissed *Peyton Place* as having minimal literary merit. Meanwhile, with some exceptions, the townspeople of Gilmanton, who claimed to recognize themselves and their quaint hamlet in this tell-all tale, ostracized their famous neighbor.

Ever since, whenever someone calls a town "Peyton Place," people understand the term's connotation. This isn't surprising, because the bestseller that contributed that evocative expression to our vocabulary broke all sales records for fiction up to that time, including *Gone with the Wind* and *God's Little Acre*. Initially, *Peyton Place* sold more than ten million copies worldwide. Only during the paperback revolution of the 1960s and 1970s did such blockbusters as *To Kill a Mockingbird*, *Valley of the Dolls*, *The Godfather*, *The Exorcist* and *Jaws* surpass it. Fifty-plus years later, *Peyton Place*'s estimated sales attained the twenty million mark. Except for another New Hampshire writer's recent record-breaking opus—Dan Brown's *The Da Vinci Code*—no

novel since *Peyton Place* has received as much media attention and raised as many eyebrows.

Yet, despite *Peyton Place*'s notoriety, the woman who made it a household name lived and died largely in the shadow of her spicy bestseller that, with its sequel, *Return to Peyton Place*, spawned two Hollywood films and American television's first primetime soap opera.

I see evidence of its author's obscure place in literary history each time that, while giving historic tours of Manchester—her hometown and mine—I'm confronted with blank stares when we stop at a three-story frame house on the northwest corner of Bridge and Ash Streets. Not until I've pronounced the words "Peyton Place" does the name "Grace Metalious," in front of whose earliest childhood home we're standing, begin to stir long-forgotten memories.

Upon learning that Grace grew up in Manchester, not Gilmanton, people express astonishment. I was ignorant of such local lore until I reached my mid-twenties. After all, I was only five when *Peyton Place* was published on September 24, 1956. Moreover, my parents neither read *Peyton Place* nor discussed in my presence the controversy that surrounded it.

My first exposure to Grace Metalious came in the fall of 1964, seven months after her death, when the soap-opera version of *Peyton Place* made its debut. Several classmates and I, eighth graders at Saint George School, yearned to watch it because our parents considered it suitable for adults only. Rumors circulated about "Grace somebody," the author of a risqué novel upon which this new television series was based, having once lived in a Victorian mansion a few blocks from our school. Daily, as I passed by that house, located at the southeast corner of Walnut and Pearl Streets, I wondered what had happened to the author, the only famous person I'd ever heard of who'd supposedly come from Manchester but whose last name none of us kids could pronounce or remember. I questioned the rumor, as, in my adolescent mind, my dull hometown couldn't possibly have given birth to anyone of great importance. Eventually, *Peyton Place* was cancelled and I forgot about "Grace what's-her-name."

In 1975, sheer coincidence rekindled my interest in Grace. At a flea market at Ash Street School, where Grace had studied, I found a hardbound copy of *Peyton Place* for fifty cents. Within weeks, while working as L'Association Canado-Américaine librarian-archivist, I happened upon a folder

Vivre la Différence

marked "Metalious, Grace." Its contents revealed that Grace was born in Manchester, she was Franco-American and she was baptized and married in my childhood parish, where her parents and mine were also married.

The more information I uncovered, the more intrigued I became with the genuine person behind the flashy façade of media hype. While scholars and critics might possibly never include Grace's novels among the literary classics, the passage of time should allow present-day readers to reevaluate her works, free from the bias of sensationalism and condemnation that clouded *Peyton Place* and eclipsed her other writings.

Besides *Return to Peyton Place*, those lesser-known publications include two novels: *The Tight White Collar*, in which Grace hints at her Franco-American background; and her autobiographical swan song, *No Adam in Eden*, a frank, often brutal story based on several generations of her family history from the Québécois countryside to the New Hampshire millscape—a thinly veiled fictional depiction of Manchester called Livingstone. *No Adam in Eden* includes occasional dialogue in perfect French. True to its title, it shows Grace growing up largely in the company of women.

If Grace's lifestyle as an adult clashed with the image of a typical small-town New Hampshire housewife of the 1950s, her childhood bore minimal resemblance to that of a Roman Catholic Franco-American girl living in the conservative atmosphere of one of New England's major textile centers. Nevertheless, her connection with her ethnic heritage, however remote, is a revelation that warrants further study to give readers a more complete portrait.

Marie Grace DeRepentigny, the elder of two daughters of Alfred DeRepentigny and Laurette Royer, was born in the old Hôpital Notre-Dame-de-Lourdes—demolished in 1976 for the new Catholic Medical Center—in Manchester's Petit Canada on September 8, 1924. Apart from this, Grace would never have significant contact with the city's Franco-American West Side, which her mother considered beneath the family's status.

Since Alfred and Laurette's third-story apartment at 104 Ash Street lay within the boundaries of Saint-Georges Parish, they had Grace christened there on September 10. According to parish records, the pastor, Reverend Thomas J.E. Devoy—later Monsignor Devoy—performed Grace's baptismal ceremony, just as they credit him with having married Alfred and Laurette. Further investigation by researcher Albert Marceau offers contradictory

evidence regarding Grace's parents' marriage, which casts doubt upon who actually christened her. The May 12, 1924 edition of *L'Avenir National* reveals that Reverend Joseph Ernest Vaccarest, a curate at Saint-Georges, performed Alfred and Laurette's wedding ceremony that same day at 6:30 a.m. The early hour was probably due to Laurette's pregnant status. When, in 2005, I interviewed Monsignor Léo St. Pierre, another curate under Monsignor Devoy, he revealed that the pastor always listed himself as officiant at weddings regardless of who had officiated. According to Monsignor St. Pierre, the City of Manchester awarded an annual prize of twenty-five dollars to whoever married the greatest number of couples in a given year. Monsignor Devoy often won. As for Father Vaccarest, who also eventually became a monsignor, there is no way of determining whether he might have also baptized Grace, as *L'Avenir National* didn't list christenings at that time.

So why should all of this matter? Because it establishes a connection between Grace and another New Hampshire Franco-American author. Keene-born writer and Dartmouth College professor Ernest Hebert, whose full name is Joseph Ernest Vaccarest Hebert, dedicated his first novel, *The Dogs of March*, "To the memory of my uncle, Monsignor Joseph Ernest Vaccarest."

From May 18 through June 8, 1958, Grace published a four-part series entitled "All About Me and *Peyton Place*" in the *American Weekly*, a Sunday supplement wherein, with the same forthrightness that she employed in her novels, she offered details about her formative years in Manchester. She wrote that her father and mother were born in Manchester to Franco-American parents. She chuckled whenever people called her a rock-bound New Englander because she considered her childhood household to have been as "un-Yankee" as possible. In fact, Grace's maternal grandmother, Aglae Péloquin Royer, who lived with the DeRepentignys for many years, spoke only French. Consequently, Grace spoke French before she learned English.

Indeed, Aglae had a profound influence on the young family. In *No Adam in Eden*, Grace portrays her "Mémère" Royer, via the character of Monique Bergeron, as an old-fashioned, domineering and frigid woman with an obsession for cleanliness. Monique performs her chores as if dust and dirt are her mortal enemies that she attacks until she has completely sterilized her

environment. According to Grace's fictional descriptions, her grandmother's attitude also extended to men and sex.

In an era when most Roman Catholics frowned upon divorce, separation and desertion, both of Grace's parents came from broken homes. Aglae ousted her blacksmith husband, Jean Royer, while Grace's paternal grandmother, Florence Marcotte DeRepentigny, was deserted by Jean DeRepentigny, a painter and iceman. As family breadwinners, both women labored in the Amoskeag mills, thus becoming strong and independent. But they raised their respective children, Grace's parents, to break out of the mill mold.

Consequently, Alfred became a skilled pressman who worked at the Granite State Press. When, in 1980, I interviewed him upon his retirement from a forty-two-year career in the Merchant Marine, he revealed that he'd once been a pressman at *L'Avenir National*, through which he'd met my maternal grandfather, Adolphe Robert, ACA president and longtime editor of its publication, *Le Canado-Américain*. And, while employed at the Clarke Press, Alfred had known my father, Henry Perreault, a Linotype machinist. My father recalled having worked with Alfred DeRepentigny, but he was astonished to learn that Alfred was the father of Grace Metalious.

By his own admission, Alfred played a passive role in the lives of Grace and her younger sister, Doris May, also called "Bunny." He told me that, like his fictional counterpart, Etienne de Montigny, "If you read *No Adam in Eden*, then you know what I mean. I was never around. I worked days, and at night I'd step out. When Grace was very young, I never got involved in baby care or anything. The grandmother [Mémère Royer], she was always there, seeing to Grace's every need."

Although Alfred loved his daughters, he felt misunderstood by Laurette, who belittled him constantly. She considered that she'd married someone beneath her, a blue-collar worker. To Grace, Laurette said that Alfred was an uncouth barbarian whose only redeeming quality was his ability to make money.

Much as her fictional counterpart in *No Adam in Eden*, Angelique Bergeron de Montigny, Laurette rejected all aspects of her Franco-American working-class heritage, most notably the French language, which she saw as a barrier toward achieving the American Dream. Grace wrote that Angelique's Franco-American friends consider her to be the cleverest among them because she speaks English without an accent, reads books that they've never heard of and acts like a mainstream American.

Grace DeRepentigny at nearly age one in the yard of her paternal grandmother's apartment, 42 Walnut Street, summer 1925. *Photo by Georgianna DeRepentigny McConnell.*

According to Grace, in real life, however rarely her mother acknowledged her ethnicity, she enhanced it, claiming French noble lineage. Grace countered bluntly: her mother descended from "Canadian farmers," and whatever nobility existed in the family came from the DeRepentigny side. She mentioned her grandfather, Jean DeRepentigny, whom she had met only once. Yet, despite the birth in Paris of either her great-grandfather or her great-great-grandfather DeRepentigny, the nobility of Grace's paternal line remains vague.

Grace wrote that Laurette harbored impossible dreams such as living in a Colonial house, being chauffeured in a limousine and traveling to Paris. She noted that people spoke behind her mother's back, saying that Laurette considered herself superior to those around her. Grace spent her youth hearing gossip about her mother's large-scale desires. Even *she* criticized her mother for such practices as buying cheap antiques to pass off as family heirlooms or telling people that the family lived in Manchester's posh North End.

A year-by-year trace in the *Manchester Directory* reveals that, with few exceptions, the DeRepentignys occupied two- and three-family houses within walking distance of their original apartment at Bridge and Ash

Vivre la Différence

Streets: 104 Ash Street, third floor (1924–25); 200 Walnut Street, first floor (1926); 251 Pearl Street, second floor (1927–32); 963 Hanover Street, single-family rented house (1933); 283 Bridge Street, second floor (1934); 40 Arlington Street, east side of duplex (1935); 753 Beech Street, second floor south (1935–42). The farthest north they lived was a multifamily house at 753 Beech Street, on the southeast corner of Beech and Blodget Streets, since demolished after a fire in the 1990s.

Obviously, Grace never occupied the Victorian mansion of my classmates' and my adolescent fantasies. Coincidentally, a slight connection to that house does exist. It once belonged to a Harrington family, owners of a liquor business whose descendant, Lawrence Harrington, served as treasurer of the Clarke Press, where Grace's father worked. Also, one of *Peyton Place*'s most prominent families is named Harrington.

Recognizing hypocrisy in Laurette's thinking, Grace nevertheless understood and sympathized with her mother's thinking, which played a major role in her own decision to become a writer. In real life, as in *No Adam in Eden*, Mémère Royer did most of the housework, thus enabling Laurette to engage in more cerebral activities with Grace and Bunny. Wishing to give her daughters a sense of culture, Laurette read them stories. On her own, Grace devoured the Nancy Drew mysteries, followed by historical and adventure novels. She then graduated to her mother's collection, including works by Dickens and Maupassant. All this occurred before she reached age eleven. By the following year, Laurette had her daughters reading the *New York Times Book Review*.

Whenever her parents argued, Grace would escape and visit her grandmother DeRepentigny, who lived nearby with her daughter, Grace's aunt, Georgianna DeRepentigny McConnell, a physical therapist who worked at home. When, in 1979, I interviewed "Aunt Georgie" in her apartment at 51 Ash Street, where she'd been living since 1936, she reminisced about her budding author niece: "Grace was a reader. She was always with a pencil and a book. She used to spend time at our house when she was a child. I know when she wasn't very old, about eight years old, she'd take a little stool in my bathtub and she'd soak in there for hours. She'd use the stool to write on, poetry and things like that, funny things that would rhyme about people she knew, 'Georgie Porgie' and stuff like that. She'd be in there and I'd say, 'Come on, get out of there. I got a patient who's got to go in there.' Even when she was married, she'd come here and take a bath and she'd write.

You never saw anybody in the world type as fast as she did—hours! Later on, when she became a writer, she gave me one of her books, *The Tight White Collar*, and she wrote in it, 'Who else has an aunt like Aunt Georgie?'"

Although in the 1930s Catholic clergymen still preached against sending children of their faith to public schools, to which many referred as "Protestant schools," the DeRepentignys couldn't afford to pay tuition at L'École Saint-Georges. Therefore, Grace received most of her elementary education at Ash Street School, directly across from her first childhood home. Within these walls her imagination, fired by her voracious appetite for reading and by her mother's dreams of a better life, produced the seeds of what would eventually blossom into a literary career.

In the fourth grade, Grace wrote what she called her first real short story. Entitled "My Brother," it got her into trouble. The teacher accused her of having fabricated a tall tale: she didn't have a brother. Frustrated, Grace lacked the words, at her age, to defend herself. Rather than write what she considered a boring assignment about a summer vacation, she'd found it more pleasing to write about an imaginary brother.

As a seventh grader, Grace penned what she dubbed her first novel, "Murder in the Summer Barn Theatre," a whodunit in which the culprit turned out *not* to be the butler but the actor who played the butler. Apparently, at this tender age, she'd committed herself to her writing.

Meanwhile, Alfred could no longer endure living with Laurette. By autumn 1936, when Grace was twelve and Bunny was ten, their father had left their mother. He eventually enlisted in the Merchant Marine and rarely saw his children again.

With her father gone, Grace, as an adolescent, often wrote stories that dealt with the search for a father figure or male hero who could rescue a young woman in distress and take care of her forever. Her only published short story in her adulthood, "Edna Brown and the Charming Prince," which appeared in *Glamour* magazine in March 1960, revolves around that theme. Despite the above, Grace projected her feelings onto her sister, declaring that Bunny suffered the most from their father's absence. By age thirty-one, Bunny had been married three times, twice to older men. Grace believed that this was her sister's way of attempting to replace the father they'd never really had.

In the *American Weekly*, Grace shared her unvarnished feelings about her father, stating that she had never truly known him. She described him as merely someone who had been around the house for a time, after which he

Vivre la Différence

had gone away. She admitted to having never had a real conversation with him. In 1958, she had no idea of his whereabouts.

In *No Adam in Eden*, Grace uses a combination of her own feelings and experiences and those of her mother to describe how Angelique, her mother's fictional counterpart, copes with being a Franco-American adolescent. In one scene Angelique's French-speaking cousins criticize her for refusing to speak their language. They mock her, calling her "petite Irlandaise" (little Irish girl).

Elsewhere, Angelique further departs from the Franco-American norm of her day. First, she graduates from Saint George Parochial School at age thirteen, which, according to the novel's omniscient narrator, is rare, as most graduate at fifteen or sixteen. Next, rather than quit school and find a job, Angelique goes on to high school. She enters "Saint Antoine's High School for Girls"—in real life, a coed institution—only to have her mother transfer her to Livingstone Central High School.

Grace paints a portrait of Livingstone High that typifies how many Catholics of the era felt about public schools, a vision that the teaching clergy and even parochial school students themselves reinforced. She emphasizes how large the school buildings are physically and how the student population, both male and female, totals more than one thousand. Angelique's classmates at Saint Antoine warn her that she'll hate public high school due to several reasons: its size, which will make her feel lost; its male students, who are destined for a life of crime; the risk of pregnancy; and the Protestant faith of its students. But according to her own mother Laurette's way of thinking, Grace shows Angelique defending her move, preferring new English-speaking friends with Yankee names to her Franco-American friends who speak with what she labels a "Canuck" accent.

While at Manchester Central High School, Grace adopted habits that reflected her mother's influence. Although her birth and baptismal certificates read "Marie Grace DeRepentigny," she told people that her full name was "Grace Marie-Antoinette Jeanne d'Arc de Repentigny," after the French queen and the French saint, not to mention that she had begun spelling her last name "de Repentigny" to give it a more noble appearance.

The January 1942 issue of *The Oracle*, Central High's literary magazine, which also served as the yearbook for Grace's midyear graduating class, features the portrait of a youthful, smiling, optimistic-looking "Grace

Franco-American Life and Culture in Manchester, New Hampshire

Grace "de Repentigny," class of 1942-B, in *The Oracle*, Manchester Central High School's literary magazine/yearbook. *Courtesy of Carpenter Memorial Library.*

de Repentigny" along with her extracurricular activities. Elsewhere, in the section entitled "The Glamor [*sic*] Girl of 1942-B Should Have…" it indicates the "Talkativeness of Grace de Repentigny," while in completing the question "Can You Imagine?" it says "Grace de Repentigny keeping quiet anywhere?" The "Class Prophecy" declares that in ten years "Grace de Repentigny is divorced, but looking toward future happiness with her lawyer, James Drury, who is becoming famous as counsel for the Checker Cab Co." Oddly enough, among the list of "Class Favorites," next to the category for "Class Writer," two names other than Grace's appear.

This omission notwithstanding, the November 1942 *Oracle*, which appeared ten months after Grace's graduation, contains what is apparently her first published piece, the only one beneath her byline "Grace de Repentigny" rather than "Grace Metalious." Entitled "Fuller Brush Man," it is a brief but poignant story about a man who fled Nazi Germany and who, despite being a brilliant pianist, sells Fuller brushes. According to Doctor David Stahl, retired Manchester dentist and a contemporary of Grace, she modeled "Fuller Brush Man" upon Ernest Einstein, a well-known Manchester figure. At the time, Einstein, who some believed was related to Albert Einstein, lived at 112 Ash Street, two houses north of Grace's first childhood apartment and directly across from Ash Street School. Written with sensitivity, the story demonstrates to what extent Grace had developed her craft at this early stage. Moreover, its publication date reflects her youthful awareness of contemporary world events, perhaps

Vivre la Différence

because of her membership in the school's International Relations Club but also due to Laurette's influence.

During this era, Grace and some friends formed an avant-garde theatrical troupe—quite an anomaly for Manchester in the early 1940s—that staged plays in the basement of the long-since demolished First Unitarian Church across Beech Street from Central High. Grace's first encounter with censorship, a sample of what she would one day endure because of *Peyton Place*, came at this time. The minister objected to a Gay Nineties melodrama that Grace had penned. It called for a male actor to appear in women's clothing. Finally, the show did go on, but the minister stayed home. Meanwhile, the church's organist, Robert Athearn, and his Franco-American wife, Luce, became involved with the troupe and often hosted rehearsals and parties at their home on Orange Street, where Grace discovered another treasured library.

In school, Grace received mostly B and C grades, but her teacher in junior English, Louis Freedman—whose son, James Freedman, served as president of Dartmouth College—felt that Grace had potential. Grace's Aunt Georgie agreed: "I knew she was college material, the way she acted and talked. You never saw a house that had so darn many books. So I said, 'If you want to go to college and work summers, I'll try to help you out.' But, instead, she got married."

Just as her fictional counterpart in *No Adam in Eden*, Lesley de Montigny, acted against her mother's wishes by marrying Gino Donati, an Italian American, Grace married George Metalious, a Greek American whom she had met at age eight while living at 963 Hanover Street and with whom she became reacquainted at Central High. Their wedding took place on February 27, 1943, in Saint-Georges Church with—again according to parish records, though no one knows for sure—Monsignor Devoy officiating. Grace's grandmother DeRepentigny and Aunt Georgie hosted the reception in their Ash Street apartment, site of our interview nearly forty years later.

From the time of their wedding until 1956, when Grace finally achieved her dream of wealth, the often penniless newlyweds had three children and struggled to survive while at various addresses in Manchester and elsewhere. They sometimes lived together, sometimes separately, depending upon the situation, as George fought in World War II and attended the University of New Hampshire both before and after his military service. For a while they had a third-floor apartment at 111 Third Street in the old German

section of Manchester's West Side. Grace also rented a room at 372 East High Street when George was away studying in Durham. According to the *Manchester City Directory* for 1952, their last residence in the Queen City was in Crystal Park, by the shores of Crystal Lake. Well before the publication of *Peyton Place*, George's career as an educator had brought the couple to New Hampshire's Lakes Region.

For Manchester readers or for anyone who wishes to make a literary pilgrimage to the Queen City, *No Adam in Eden* stands out as the most locally oriented of Grace's novels. Besides the corner of Bridge and Ash Streets, Saint George Parochial School, Saint Antoine's High School for Girls and Livingstone Central High School, it mentions other landmarks: Deer Park (Derryfield Park), the Northeast Manufacturing Company (Amoskeag Manufacturing Company), the Pilgrim Ice Cream Parlor (the Puritan Restaurant, formerly at 897 Elm Street, or perhaps the Puritan ice cream stand on Daniel Webster Highway North) and undoubtedly Grace's favorite refuge, the Livingstone Public Library (Carpenter Memorial Library).

Grace wrote *No Adam in Eden* shortly before her death, almost in a race against time, as she realized that her years of poverty followed by more years of riches and partying had taken their toll. The novel reflects a dark view of life as seen through the eyes of one of its victims, the last of several generations of unfulfilled women.

As with many second-generation ethnic Americans of her era, Grace never quite fit into the mold that her cultural heritage had cast for her, nor was she able to completely break from that mold to become part of mainstream American life. In this sense, she closely resembles another Franco-American writer born two years before her, some thirty-odd miles down the Merrimack River in Lowell, Massachusetts. Jack Kerouac, father of the Beat Generation and author of the classic *On the Road*, also lived a marginal life, caught between two cultures. And, just as with Grace, his bestseller eclipsed his more introspective Franco-American writings such as *Visions of Gerard* and *Doctor Sax*. Kerouac's excessive lifestyle brought him to the end of his road in 1969 at age forty-seven. But, unlike Grace, his literary reputation has since soared to heights that he could never have imagined.

As for Grace Metalious, whom those close to her have described as "intelligent, kind, compassionate and generous" or as "a delightful and refreshing girl to be with" and as a "bubbly life-loving young lady," the

Vivre la Différence

limelight proved to be a mixed blessing. She had not prepared herself to swallow the bittersweet pill of success coupled with public scorn, troubled marriages, financial exploitation and alcoholism, all of which sent her to an early grave by February 25, 1964, at age thirty-nine, not long after having become a proud grandmother. She was buried in a remote corner of Gilmanton, New Hampshire's Smith Meeting House Cemetery, where she finally found peace in death that often eluded her in life.

The following year, George Metalious and June O'Shea co-wrote a biography entitled *The Girl from Peyton Place*. But, with time, Grace's books went out of print while she gradually faded from the public's memory. The year 1981 saw the publication of a twenty-fifth-anniversary edition of *Peyton Place*, as well as Emily Toth's biographical literary critique, *Inside Peyton Place: The Life of Grace Metalious*. Still newer editions of *Peyton Place* (1999) and *Return to Peyton Place* (2007) have appeared through University Press of New England, both with introductory essays by scholar Ardis Cameron. Novelist Barbara Delinsky also paid homage to Grace in *Looking for Peyton Place* (2005). Set in a fictional New Hampshire town, it features a female protagonist who draws inspiration from the spirit of Grace Metalious.

In recent decades, colleges and universities have offered courses on women's literature that occasionally highlight Grace as an early feminist writer, a label that would perhaps have surprised her and which she might have disputed. In addition, courses, books, films and public lectures dealing with popular culture of the 1950s usually incorporate the *Peyton Place* phenomenon, sometimes without mentioning Grace by name. One fact appears obvious: considering the worldwide sensation that surrounded Grace and *Peyton Place* in the 1950s, she and her works remain largely unknown among most people born after her death.

The fiftieth-anniversary celebrations of both the novel and film versions of *Peyton Place* in 2006 and 2007, respectively, somewhat jogged the public's dormant memory of Grace Metalious. Manchester Central High School, whose Hall of Fame includes Grace, organized a "50 Years of Grace" festival, while the town of Camden, Maine, where *Peyton Place* was filmed, had a Grace Metalious weekend. Speculation about a film project on Grace's life, featuring Sandra Bullock in the starring role, also has the public's attention. Finally, on a less serious note, the New Hampshire Historical Society issued a Grace Metalious figure in its "bobblehead" series.

"Pandora in Blue Jeans" dust-jacket photo of *Peyton Place* author Grace Metalious, 1956. *Photo by Larry Smith.*

Vivre la Différence

At the very least, after a half-century, Grace's writings, which many readers now agree are of a much higher quality than originally thought, deserve the serious critical analysis that she so desperately sought but which the reactionaries of her era succeeded in denying her.

Dreamer that I am, I long to see a memorial erected in honor of Manchester's famous novelist. I envision a statue modeled after Larry Smith's *Peyton Place* dust-jacket photo. Entitled "Pandora in Blue Jeans," it shows a seated Grace Metalious dressed in her classic plaid shirt, jeans and sneakers but no socks. She is staring down at her typewriter with a brooding expression, fists covering her mouth, elbows bent and being supported by her knees, with her feet resting on the lower shelf of her typing table.

In my dreams, this statue sits at the northeast corner of Bridge and Ash Streets, on the grounds of the former Ash Street School, where Grace learned to love reading and writing. The corner also faces her first childhood home and is diagonally across from where the Fuller Brush man lived. In *No Adam in Eden*, Angelique always met her boyfriends at that corner.

On the statue's base, a plaque reads: "Grace DeRepentigny Metalious. Born September 8, 1924, in Manchester, New Hampshire. Died February 25, 1964, in Boston, Massachusetts. Author of *Peyton Place, Return to Peyton Place, The Tight White Collar* and *No Adam in Eden*." Below that inscription reads a poem:

"Pandora in Blue Jeans"

Not once, not twice,
but more than thrice,
she told the truth.
Left out the sugar,
but not the spice.

Some said "uncouth."
Others said "not nice."
And in the end
they all made sure
she'd pay the price.

*Since time has passed
we've fought the fight
to let them know
that she was right.*

*And now at last
she's won her place.
So here's to you,
our Amazing Grace.*

OLD PAROCHIAL SCHOOL DAYS

Founded in 1890, the third among Manchester's eight Franco-American parishes, Saint-Georges Parish encompasses the northeastern part of the city, a mixed area in socioeconomic, religious and ethnic terms. Its parochial school, L'École Saint-Georges (1898–1970), which we children of the final generation called "Saint George School," operated under the direction of the Sisters of Holy Cross and the Seven Dolors. Its early history resembled that of most similar educational institutions. Everything changed in the mid-1920s when the pastor, Reverend Thomas J.E. Devoy, was accused by *La Sentinelle* and the newspaper's supporters in his parish of wanting to anglicize the students of L'École Saint-Georges.

For the next few decades, while remaining essentially Franco-American and bilingual, the school's ambiance—with the exception of a few dedicated teachers of French—did little to encourage students to learn about and practice their Franco-American culture outside the classroom. Conversely, upon his nomination as pastor of Saint-Georges Parish in 1960, Reverend Adrien Verrette, ex-Sentinelliste and promoter of *survivance*, launched a personal campaign to restore French spirit among the youth of the parish. Despite his efforts and those of his partisans, the educational and financial situation necessitated the closure of L'École Saint-Georges in 1970.

Having grown up in a familial atmosphere wherein my parents spoke exclusively French to me during my first three years, to then expose me to English, I was able to enter first grade at Saint George School in September

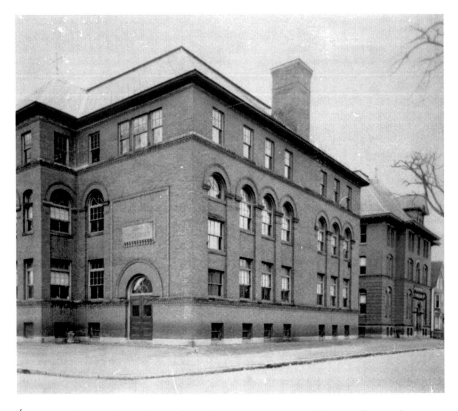

École Saint-Georges (Saint George School), northeast corner of Pine and Orange Streets, circa 1945.

1957 at age six, already equipped with the linguistic and cultural baggage required for success in a bilingual educational system. At that time, unlike some schools that offered French as a second language for one hour per day, Manchester's Franco-American schools, including ours, continued to use French as a vehicular language during half of the school day, the other half being devoted to English. I belonged to the last class in our school's history to have spent its eight primary years under this system. In the fall of 1965, three months after our graduation, Saint George joined a growing number of Franco-American schools that reduced their French classes to one hour per day, as fewer students were entering first grade speaking French fluently.

During the period in question, the student population at Saint George numbered between 550 and 600. We were divided into eight grades—kindergarten having existed before and after my classmates and I were of age to attend—each of which was subdivided into two classes with roughly

Vivre la Différence

35 to 40 students per class. Each grade had a teacher of French and one of English. One class had French in the morning and English in the afternoon, the other class having the opposite schedule. Unlike some Catholic schools, we wore no uniforms. Meanwhile, discipline was strict, as corporal punishment still existed. The level of its severity and the frequency of its administration depended upon each individual nun. Parental attitudes in this regard varied, as some believed that their child got what he or she deserved, while others objected to any form of corporal punishment. I recall one nun who never laid a hand on anyone but had her students strike themselves on the tops of the knuckles with a ruler. Unlike today's classes, perhaps half the size of ours—not to mention that nowadays schools often have teachers' aides— our nuns single-handedly maintained discipline.

With few exceptions, Québec-born nuns taught French while Franco-American sisters, and occasionally those of Irish-American background, taught English. Other than the first few grades, during which we learned to read, write and count, the educational program consisted of the following subjects:

English class: arithmetic, spelling, grammar, reading, history, geography and science, all subjects required by New Hampshire state law.

French class: *catéchisme*, *épellation* (spelling), *grammaire*, *lecture* (reading). Although my mother, Madeleine Robert, studied the history of Canada at L'École Saint-Georges in the 1920s, by the time I arrived it was no longer taught, though a few of my contemporaries from other Franco-American schools in Manchester have told me that it was included in their curriculum.

At Saint George, besides the above, the school offered a choice of extracurricular activities:

For boys: altar boys, Cub Scouts, Boy Scouts.

For girls: church choir.

For both sexes: school plays and talent shows in both languages, "Festival de la Bonne Chanson" (Festival of the Good Song, a citywide French choral competition), regional French essay and speech contests, spelling bee in English, piano lessons offered by the nuns at reasonable rates.

To succeed, a student had to, at least theoretically, be perfectly bilingual upon entering first grade. We were there to learn to read and write the two languages that, in principle, we already spoke fluently. Yet, in my first week in first grade, I noticed that the degree of knowledge of French, of English or of both languages varied among my classmates. For the majority, whose grandparents and parents were born in Québec and in the United

States, respectively, English outweighed French. However, most understood and expressed themselves well enough in French despite minor difficulties: determining the gender of nouns and the correct verb tenses or avoiding anglicisms. A few students born in the United States, but whose parents were natives of Québec, had a nearly equal mastery of both languages. Meanwhile, the tiny percentage of students who themselves were born in Québec were weaker in English. Finally, at the opposite extreme were young Franco-Americans who could barely pronounce their names in French, either because their families had been in the United States for several generations or because they were of mixed parentage. Without linguistic support in French at home, the latter students languished in French class for a few weeks or months, after which they transferred to another school.

Regardless of their ease or difficulty vis-à-vis one language or the other, students in the 1950s and 1960s favored English in all of their oral communications, except for during French class, where English was forbidden. Even there, certain students tempted fate by attempting to speak English with the French teacher. I often heard my classmates ask or say, "Why do we have to study French? We hate it. We're ashamed or embarrassed to speak it. It's so hard. It's useless. It's old-fashioned." It was with this attitude that many young Franco-Americans began their primary course of study.

As for the nuns, whose point of view I obtained through interviews with Sister Liliosa Shea, my English teacher in grades four through six, and Soeur Alice Léonard (formerly Soeur Alice des Anges), my eighth-grade French teacher, all of the above was part of the challenge to which their vocation called them. Their purpose being the solid spiritual and scholastic formation of their students, the nuns spent long days working tirelessly to promote the Catholic faith, the French language and the Franco-American family, for which they received minimal material remuneration. Although each teacher had a certain level of autonomy in her own classroom, all had to comply with the State of New Hampshire's educational requirements as well as with rules established by the Holy Cross community's prefect of studies. The latter developed a curriculum in collaboration with the principal of every school, while leaving each teacher a certain degree of freedom in the selection of textbooks.

In English class, the atmosphere resembled that of any English-language Catholic school since, with few exceptions, the program consisted of the

Vivre la Différence

same subjects. This was confirmed for me by my friend, Steven Dennis, who studied at the McDonald School, formerly the parochial school of Saint Anne's Parish in Manchester. The significant difference between our schools was that while we at Saint George had our French class, students at McDonald had catechism in English, as well as other subjects not offered within our curriculum.

At Saint George, all but one of our English teachers spoke the language impeccably well, the exception being our seventh-grade English teacher, who had a thick French-Canadian accent. Consequently, students could perfect their command of the language in which they expected to function as adults in American society. For English class, the school provided all textbooks, but we had to buy our own workbooks. While our workbooks, especially those for arithmetic and English grammar, always looked up to date, the textbooks we got for free were often old. I recall our eighth-grade history textbook in 1964–65 ending with World War II. Because most of our books came from Catholic publishers, regardless of the subject, they had a decidedly religious flavor. Meanwhile, a few were secular—for example, our first-grade reader, featuring the adventures of Dick and Jane.

French class was obviously where Franco-American parochial schools differed from all others. Our nuns never spoke standard French, what some call "Parisian French" despite there being a variety of accents throughout France. As in most Franco-American schools, the nuns spoke and taught grammatically correct North American French, which any educated Francophone in the world would have understood. Besides a different accent, it consisted of Canadianisms, regionalisms, archaic French words and words borrowed from Canadian Indian languages. For comparison's sake, the teaching of North American French in Franco-American schools was similar to the teaching of American English rather than British English in U.S. schools.

Well aware of the linguistic milieu of her Franco-American students, each teacher of French painstakingly corrected their grammatical errors, their anglicisms and all other imperfections with great precision, if not always with equal kindness. In addition, while teaching us to read and write French, the nun would point out the nuances between spoken and written French, much as a teacher of proper English might tell a student to write, "I'm *going to* do my homework" rather than "I'm *gonna…* " I recall having spent countless hours learning all the parts of speech, parsing sentences and conjugating verbs in every possible mood and tense, except for *le passé simple*—the literary

past—which our seventh-grade French teacher said she'd ignore because she saw no future authors in her class. How I wish I could meet her today, as I'd have plenty to say to her about my struggles with *le passé simple*.

Our French books came from various sources, including one of local interest. In her workshop at the Manoir Saint-Georges (Saint George Manor) on Island Pond Road in Manchester, Soeur Marie Clément de Rome conceived and printed typewritten *épellation* and *grammaire* exercise books. Our readers came from Québec and, for the most part, were outdated. Since, by this time, our school's French curriculum no longer included the history of Canada, these readers, despite their age, were our only resource for learning about our French North American heritage. But, by their very nature, they served merely for purposes of reading comprehension and vocabulary building. In other words, if students used them as a source of information about Québec, they did so voluntarily out of personal interest, as the program did not include Québec studies as a subject.

Other than the French language, another reason for the existence of Franco-American schools was the daily *leçon de catéchisme* that the nuns gave according to the *survivance* ideology that linked the maintenance of our faith to the preservation of our mother tongue. Our textbook was the French-language version of the *Baltimore Catechism*. In addition to Catholic religious doctrine, the nuns taught us biblical stories, the history of the Catholic Church, the function and symbolism of sacred vessels and liturgical vestments and the significance of holy days. We also studied diocesan and parochial history, such as the names of our local bishops and Saint George's pastors.

As in all Catholic schools, religion played a major role in our education. We began and ended every class session, recess and lunch period with prayers—always in French, even in English class. Many of us learned our prayers in English only in high school. In observance of the nine first Fridays of the month, the nuns brought us to church to confess our sins, to attend Mass with obligatory communion and to take part in the benediction of the Blessed Sacrament. During Lent, they urged us to go to daily Mass and receive communion before class, with obligatory presence at the Way of the Cross every Friday afternoon. During May, the month of Mary, we were encouraged to attend Mass as frequently as possible and were required to participate in the Marian procession in the streets around our church on May 31.

Vivre la Différence

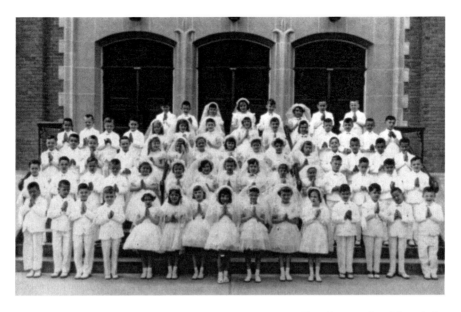

First graders of Saint George School at the occasion of their First Communion, May 1958.

Having been taught my prayers by my mother and maternal grandmother beginning at age four, followed by religious instruction within the above-mentioned context, in my childhood imagination, I assumed that God, angels, saints and biblical figures were all Franco-Americans who spoke only French, the official language of heaven. To me, prayer and religion made no sense in English.

Apparently, others had come to similar conclusions, including the Franco-American writer David Plante. In his novel, *The Country*, he wrote: "Their religion was my religion, the religion of a God who spoke an old parochial French, who said, 'moué' and 'toué' for 'moi' and 'toi', 'ben' for 'bien', 'à c't'heure' for 'maintenant', 'broyer' for 'pleurer'. In his old French, God talked to us about sin, ashes, the devil and hell. In English, he was strange. But not in French. When I thought about him and his religion in French, he and his religion were familiar. I prayed to my Canuck God."

I was also convinced that non-Catholics would never get to heaven but that God would allow Anglo-Catholics to enter despite their incomprehensible prayers because they practiced the "correct" faith. Imagine, then, my consternation upon learning from my father, around age nine, that Jesus and the biblical figures had neither spoken French nor were they Franco-

Americans, but rather, they were Jews. I then shocked my parents by retorting that I wished I'd been born Jewish, to be like Jesus.

Regardless of students' misperceptions, the nuns did their best to fulfill their mission to produce and train future soldiers of Christ via the solid base of our school's moral structure. For my generation, this religious upbringing occurred in an era of national anxiety over the Cold War. Although our school's basement was an officially designated Civil Defense fallout shelter, I never heard the phrase "duck and cover." Rather, we were told to pray for the conversion of Russia. The nuns also reminded us of our duty as defenders of the faith. They told us that if Communist soldiers invaded the United States, they might come to our school. Upon entering our classroom, they would rip the crucifix off the wall and force us, each our turn and under penalty of death, to spit on it. We were expected to refuse and instead prepare to suffer martyrdom in God's name. If, today, all of this seems exaggerated, many of us, as children, took it seriously.

Besides being guardian of the faith, the Franco-American parochial school could also inspire religious vocations. Without actively recruiting, certain nuns supported students who appeared to have a vocation. A few of my friends and I, as altar boys, were convinced that we were destined for priesthood. Consequently, the sacristan, a nun also in charge of altar boys, befriended us. From her trips to visit family in Québec, she'd bring us back miniature sacred vessels. An excellent seamstress, she also made us all priestly vestments in our size, as we each had a small altar in our room at which we "played Mass." Upon learning that we used Necco wafers for communion, she supplied us with unconsecrated hosts. Nonetheless, by early adolescence, I discovered girls.

Regarding altar boys, our school's administration always made sure that we had French class in the morning, a time during which we sometimes had to serve at funerals. Apparently, English class was considered the more important of the two half-days, never to be missed. Sisters Liliosa and Alice, as well as our former pastor, Monsignor Adrien Verrette, whom I also interviewed, confirmed this.

As for religious vocations, on several occasions, especially during eighth grade, representatives from various religious orders in search of possible candidates visited our class. A few of us boys spent a weekend at the Oblate seminary in Bucksport, Maine. I also recall a young missionary nun who

Vivre la Différence

shared stories of India, hoping to inspire some of the girls to follow in her footsteps. Whenever someone expressed interest in the religious life, the nuns would ask his or her classmates of the opposite sex to avoid luring the student away from his or her budding vocation.

This leads to yet another topic: sexuality. At Saint George, despite our eighth-grade English nun's preference for the word "politeness" in reference to sexuality, our teachers tackled the subject without fear. Upon hearing, "Today, we're going to have a politeness lesson," we all knew what was about to happen. Depending on the specified topic, the nuns would either keep us together or would separate the girls from the boys. In a relaxed atmosphere and in a frank and sensitive manner, we shared our ideas, our feelings and our difficulties, all the while receiving direct answers to our questions. From time to time, these conversations involved the physical or biological aspects of sexuality, though most of the time, they touched on issues of morality and responsibility.

At Saint George, as in Franco-American schools elsewhere, our half-day of French meant sacrificing other subjects and activities that students in Anglo-Catholic and public schools took for granted. For example, we studied neither art nor music, which were introduced only after my class had graduated. We had no physical activities, no gym class, no sports teams, no Catholic Youth Organization (CYO). A third-story assembly hall had fading painted lines on its worn wooden floor, suggesting a long-abandoned basketball court. While we learned to perfect our French, children in other schools sometimes left the classroom for an educational field trip.

Sister Liliosa offered one exception to the above. A gifted artist who eventually chaired Notre Dame College's art department, she used her talent as an educational tool to create blackboard-length collages/murals that illustrated a theme within our course of study. For example, in sixth grade, during a unit on the American Revolution, students collaborated on a giant image depicting various historical events, including the Boston Tea Party and the signing of the Declaration of Independence. That same year, we had a new student in class who, despite a serious learning disability, possessed extraordinary artistic aptitude. Rather than pay attention to lessons beyond his intellectual capacity, he drew in as discreet a manner as possible. While the French teacher occasionally caught him red-handed and tore his drawings, Sister Liliosa, who recognized his capability vis-à-vis his handicap,

not only allowed him to draw in her class but also praised his work in our presence. Her kindness toward this student, as well as her understanding of his unique situation, impressed me as a child, and more so in retrospect.

Other than the above-mentioned shortcomings, ours and many other Franco-American schools failed to nurture pride in our ethnic identity. Granted, they provided an excellent French linguistic course of study, but they neglected the language's cultural aspect, which would have given us a sense of belonging to the Francophone community. In French class, we were told, "Speak French because it's your language." To me as a child, that resembled a mother's warning, "Eat your spinach because it's good for you." The nuns never gave a concrete, valid reason for speaking French. Yet they weren't entirely responsible for these gaps in our education, functioning as best they could, often in difficult, complex circumstances.

Such circumstances resulted from an evolutionary process. When our ancestors first arrived in New England from French Canada, most spoke French not only out of habit but also because of their conscious desire to preserve their mother tongue. They founded institutions devoted to the defense and maintenance of Franco-American life. Parents sowed the seeds of Franco-American identity among their children via the French language, Catholic faith and cultural traditions. Then, equipped with these essential elements, children entered parochial school, where they had the seeds of their Franco-American identity spiritually and intellectually nourished in their catechism, French language and history of Canada courses. Moreover, Franco-American parochial schools aided students in adapting to American society by teaching them English, U.S. history and other indispensable subjects.

Between the Civil War and the Depression, the Franco-American population received continuous transfusions of cultural blood, thanks to a constant flow of immigrants from Québec. In addition, family ties on both sides of the border remained close so that Franco-Americans often visited Québec, where they bathed in the cultural waters of the motherland. During this era, parochial schools received moral and sometimes financial support from families, from their respective parishes and from other Franco-American institutions, so that, despite the perfectly natural thinning of cultural identity from generation to generation that affected all ethnic groups, the schools could nevertheless succeed in their educational goals. However, this golden age in the history of Franco-American parochial schools would prove to be ephemeral.

Vivre la Différence

Despite the efforts of numerous champions of *survivance*, the period between the two world wars brought profound changes within Franco-American institutions. The Americanization campaign of the 1920s, followed by the downfall of the Sentinellistes, not to mention the effects of the Depression, all served to accelerate the acculturation of the Franco-American population, including its most impressionable members: its youth. From this time onward, throughout New England, more and more Franco-American children entered first grade less prepared to follow the French-language portion of the parochial schools' curriculum. Consequently, if parents were already beginning to neglect their role as sowers of seeds of Franco-American identity among their offspring, how could parochial schools be expected to nourish what barely existed? Without the support of the Franco-American family—the very foundation of ethnic solidarity—the schools had two choices: either evolve with the times to become less Franco and more American, or maintain the status quo and risk losing a significant portion of the student population.

Although the above-mentioned situation existed across the region, at Saint George, the acculturation process was somewhat accelerated through the efforts of Monsignor Devoy, who remained pastor well beyond the Sentinelliste conflict, until his death in 1948. By the time I entered first grade nine years later, little had changed. Although the school still offered a half-day of French, limited attention was paid to cultivating our sense of identity and pride in our Franco-American heritage, nor did the nuns emphasize how the French language could be practical for us in the future.

People often ask, "Why do so many Franco-Americans lack ethnic pride?" to which some reply, "Because we have no heroes to inspire us." Actually, we have no shortage of heroes, but rather, we don't recognize them. I recall, in one of our American history lessons, having learned about explorers such as Columbus, Balboa and Magellan. Among others were Champlain, Jolliet, Marquette and La Salle. Had someone mentioned that we shared the same blood, heritage and language as the four latter ones, we, as young Franco-Americans, might have identified them as our people's contributors to the history of North America. But all were merely grouped together, the French with the others.

When, as an adult, I learned the names of many important Franco-Americans closer to us in time and from a geographical standpoint, I wondered why no one had mentioned them in school. To name but a few:

Calixa Lavallée, Québec-born musician who joined the northern army during the Civil War, lived in Lowell, Massachusetts, and composed the music for the Canadian national anthem, "Ô Canada";

Napoléon "Larry" Lajoie of Woonsocket, Rhode Island, professional baseball Hall of Famer;

Eva Tanguay of Holyoke, Massachusetts, singer, actress and vaudeville star;

Lucien Gosselin, Manchester sculptor, whose works adorn parks and buildings here and elsewhere;

Will Durant of North Adams, Massachusetts, historian and philosopher, coauthor of *The Story of Civilization*;

Jack Kerouac of Lowell, Massachusetts, bestselling author of *On the Road* and many more Beat Generation and Franco-American books.

A course in Franco-American history would have fostered a greater appreciation for the French language among students. Likewise, in the upper grades, the nuns could have assigned us to read works of literature, such as Québec author Reine Malouin's young-adult novel *Où chante la vie*, whose setting is Manchester and which Malouin wrote at the request of our pastor, Father Verrette.

But it was not during the 1950s or 1960s that educators thought of such things, neither at our school nor elsewhere. Consequently, with few exceptions, it is doubtful that Franco-Americans of my generation, having never been exposed to the cultural richness of our ethnic group while in parochial school, know and seek information about these topics today as adults and as parents. And so they are raising a new generation whose members are even less aware of their Franco-American identity.

Again, the nuns can't be held completely responsible for these deficiencies. As natives of Québec, those who taught French had studied French-Canadian history and literature rather than those of Franco-American New England. Meanwhile, Franco-American nuns who taught English already had a heavy workload. Besides, it would have made more sense to include Franco-American subject matter within the French half of the curriculum to help validate the language. Finally, the greatest challenge to educators of the past lay in the very nature of the Franco-American publishing world. Often, the best Franco-American historical and literary works were—and continue to remain—rare or inaccessible. During the period in question, long before the existence of the National Materials Development Center for French (1975–82), which published new editions of many out-of-print Franco-American books, the nuns would

Vivre la Différence

have encountered numerous obstacles had they searched for such texts. On May 8, 1960, his thirty-ninth anniversary of priesthood, Reverend Adrien Verrette became pastor of Saint-Georges Parish, where he had served as a curate in the early 1920s during Monsignor Devoy's pastorate. Having witnessed firsthand the latter's effort to anglicize and acculturate the youth of the parish, Father Verrette immediately began reversing this decades-long trend. Within weeks, everyone realized that this new pastor, one of my maternal grandfather's best friends, would be bringing significant changes to our school

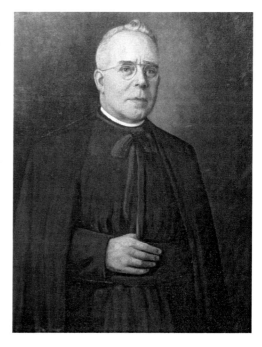

Reverend Adrien Verrette, author, historian, Franco-American activist, 1949. *Oil painting by Lorenzo de Nevers.*

and to the parish in general. With no official jurisdiction over the curriculum, Father Verrette nevertheless succeeded in transforming our school's atmosphere. On May 24, 1960, students participated in a program marking the tricentennial of the death of Adam Dollard des Ormeaux, a French military officer, at the hands of the Iroquois in the Battle of Long-Sault on the Ottawa River. It was a new experience since, before Father Verrette's arrival, I—and most likely my classmates—had never heard of Dollard, whom Québécois historians now consider to be a controversial figure, which didn't prevent my classmates and me, as sixth graders in 1963, from reenacting Dollard's exploits in a school play.

This was the era of "re-Frenchifying" ourselves. Henceforth, we would celebrate every French or French-Canadian feast day or Catholic holy day by staging a play, giving a concert or reciting patriotic or religious texts, entirely or at least overwhelmingly in French, in front of an audience comprising the pastor, his curates, special guests, the nuns and students. Usually, students chosen to perform were those most gifted in French, often those whose families were active participants in the parish or in Manchester's Franco-American cultural affairs.

Father Verrette often reminded the principal that, outside of the classroom, regardless of whichever language the nuns taught, he expected them to speak only French with students, as well as require students to respond likewise. When distributing report cards—always praising students who succeeded in French—the pastor encouraged us to speak French amongst ourselves at recess and elsewhere. Finding this both embarrassing and awkward, few students complied. Meanwhile, each of us received, free of charge courtesy of Father Verrette, a copy of Manchester's weekly French-language newspaper, *L'Action*, which we were told to bring home to read with our parents. By all indications, few of these newspapers arrived at their destination. Father Verrette also undertook enormous projects, for example, the renovation of the church, the rectory and the grammar school. He financed these in part by charging tuition—one dollar per month per child—unaffordable for certain families and unheard of, at least under Father Morin, Father Verrette's immediate predecessor. Finally, during his ten-year pastorate, Father Verrette, who became Monsignor Verrette in 1966, wrote and published seven pamphlets that covered, nearly day-to-day, Saint-Georges Parish's history from 1890 to 1970.

Certain parishioners welcomed these changes while others, especially the young, felt that the parish was becoming too French. Some transferred to an English-language parish. Also during this era, the school hired a few lay teachers due to the decreasing number of religious vocations. Consequently, our school's financial status suffered. In the end, it is that, rather than the acculturation of the students, that caused L'École Saint-Georges to close in June 1970.

From 1970 to 1984, our former school served as a daycare center, a senior citizens' club and a mental health facility. On two occasions, I visited my alma mater: the first in 1978, when Montréal filmmakers Daniel Louis and Jean-Claude Labrecque interviewed me on the premises for their 1980 documentary on Franco-Americans, *Bien des mots ont changé* (Many Words Have Changed); and again in 1985 when, after major interior renovations, I attended an open house of the new École Saint Georges Apartments. I also returned there in my imagination by having used it as the fictional setting for my first short story, "L'Escalier interdit" (The Forbidden Staircase), published in France in 1981.

These visits and the writing of the present essay have caused me to reflect on the value of my education at L'École Saint-Georges, which I perceive

Vivre la Différence

Eighth-grade graduates of Saint George School, June 1965. *Photo by the Camera Shop.*

with a mixture of sentiments. Granted, it was a happy time in my life, thanks to—minus a few exceptions—good, devoted teachers and sympathetic classmates. Because we all practiced the same faith and belonged to the same ethnic group—though a few students had last names of Irish, Portuguese or other origins but whose mothers were Franco-American—we shared a family spirit that rarely exists in schools where students and their teachers come from various backgrounds. We studied in a comfortable and secure environment, where the educational level was above average because our teachers knew their material and taught it with enthusiasm.

Conversely, this environment, ideal for learning by rote but not always for how to think independently, also overprotected us, keeping us naïve and sometimes unprepared to face our future in the outside world. In *Walden* (1854), Henry David Thoreau referred to this notion by describing a French-Canadian lumberjack whom he encountered in the woods near Concord, Massachusetts: "But the intellectual and what is called spiritual man in him were slumbering as in an infant. He had been instructed only in that innocent and ineffectual way in which Catholic priests teach the aborigines, by which the pupil is never educated to the degree of consciousness, but only to the degree of trust and reverence, and a child is not made a man, but kept a

child." A century later, we weren't as wanting as Thoreau's lumberjack. Yet our grammar school education should have rendered us more conscious of our Franco-American identity while leaving us better equipped to confront the challenges of an Anglo*phile*, often Franco*phobe* society.

In our school's homogeneous atmosphere, mocking a classmate for ethnic reasons was naturally nonexistent. By contrast, in the multi-ethnic ambiance of a diocesan or public high school, Franco-Americans suffered being called "stupid frog" or "dumb Canuck." Meanwhile, a few high school teachers of French ridiculed Franco-American students because of our North American French accent. At the time, I couldn't understand why Franco-Americans, being neither better nor worse than any other ethnic group, deserved such treatment. And, as for the linguistic question, I knew that most Franco-American students could get along well enough in French, sometimes with even greater facility than certain Anglophone teachers of French who had learned the language in school and spoke so-called Parisian French with a thick American accent. But being ignorant of the value of their ethnic heritage, which they were unable to defend, a good number of Franco-American students failed and/or dropped French class in high school. Some even went so far as to stop speaking it altogether and try to hide their ethnic origin.

Later in life, I learned that such discrimination, though in a different form, also existed in the labor market, where Franco-Americans were often forced to accept menial, boring jobs for little pay. Taught by the nuns to be humble, to accept their lot and to offer it up to God for a better place in heaven, many Franco-Americans lived by the old saying, "*On est né pour petit pain*" (We're born for little bread). Had parochial schools cultivated our sense of Franco-American identity and pride while preparing us to deal with the above-mentioned challenges, we might have been better able to overcome these obstacles. In the end, most forsook French in favor of English to pursue a career in service to the general public. A minority achieved success in French as professionals and businesspeople within the Francophone community. Still others used their bilingualism to function in both worlds.

During my adolescence, given my inner turmoil over my family's ethnic pride, which I understood poorly, vis-à-vis the discrimination I sometimes witnessed, I didn't completely abandon the French language and Franco-American culture but simply set them aside. In subsequent years, thanks to

Vivre la Différence

a series of experiences that influenced my thinking, I not only reconciled myself with my Franco-American heritage but actually embraced it.

The first incident occurred in 1970, when I attended the Strawberry Fields Rock Festival outside of Toronto with several friends, none of whom spoke French. Although he'd never heard me speak French, one of my friends brought two hippie girls to me, asking if I could help them. They were Québécoises. One was frantic and the other looked ill. The frantic girl was relieved to finally meet someone who understood French. Her friend was suffering from a bad LSD trip. Upon our return from having brought the girls to the medical tent, where I had interpreted for them, my friends were in awe: "Wow, you sounded so different in French, like you were another Bob we never met before." This brought to mind my grandfather's motto about a person knowing two languages being worth two people. For the first time ever, speaking French, an act I'd taken for granted, had suddenly become special. I could actually do something that my friends couldn't, and they seemed envious. I was equally blown away by my having met hippies who spoke French. Up to then, although I had Québécois cousins of my generation, I had always viewed French as belonging to my grandparents' and parents' generation—in other words, to the past. Suddenly, I could identify with my mother tongue on a new level.

Then, in 1971–72, encouraged by my professor of French at Saint Anselm College, Roger Blais, I studied in Paris. Again, my knowledge of French—especially its grammatical aspects, which the nuns had drilled into our heads—took on greater value when a few of my Anglo-American classmates consulted me regarding their French homework. Since most came from elsewhere in the United States and had never heard of Franco-Americans, they considered me fortunate to have grown up in home and school atmospheres where French and English occupied an equal level. That gave me a new appreciation for my bilingual education.

After college, on a whim and in desperation due to the poor job market, I included my fluency in French on my résumé. It led to a position that I could never have imagined: chief research assistant and oral history interviewer to Tamara K. Hareven and Randolph Langenbach, authors of *Amoskeag: Life and Work in an American Factory-City* (1978). Because they needed someone to interview former Amoskeag textile workers, many of whom spoke little or no English, they hired me for my French-language skills and my familiarity with the Franco-American community. Besides having provided me with the

ultimate proof that French could be a useful, viable language in the United States, this position set me on my career path.

To arrive at this point, I'd gone through a three-step process: the sowing of the seeds of French at home; the nurturing of those seeds at L'École Saint-Georges; and their blossoming via adult experiences described above. Had any of these elements been lacking, today I'd be earning a living in God knows what field.

In conclusion, I admit that, were I to relive my primary education, given the choice, either a monolingual Anglophone school or a bilingual Franco-American one, I would, without question, select the latter. Unfortunately, our son, Charles, who is perfectly bilingual, will never have that choice. Alas, the old Franco-American parochial school system from which we—that is, my wife, Claudette, and I—benefited no longer exists. Such is the dilemma we face.

Author's note: Since the writing of a slightly different French-language version of this essay in 1986 and its publication in 1990, Saint-Georges Parish closed in 2002. Meanwhile, Charles, now twenty-eight, continues to be perfectly bilingual, having learned to read French as a child via bedtime stories and to write it at Manchester High School West, at Saint Anselm College and during a semester in Aix-en-Provence, France.

NEIGHBORHOOD AT A CROSSROADS

Dawn. Picture yourself atop a hill in an area called Notre-Dame. Across the winding blue ribbon of water baptized "Rivière du Guast" in 1605 by Samuel de Champlain, the sun rises. On the river's west bank, in the steeple of a nearly century-old church, Sainte-Marie, the Angelus bells toll.

Stay a while, listen closely and your ears capture the echoes of early morning conversations bouncing back and forth across the neighborhood: expressions that would make King Louis XIV smile and feel at home; words pouring from the lips of silver- and white-haired ladies as they walk along streets named Dubuque or Hévey on their way to daily Mass that *Monsieur le Curé* or one of his *vicaires* celebrates in their mother tongue.

Wander a bit and you discover a nearby pharmacy, Gosselin's, where, on the newsstand, you find *La Presse* and *La Tribune* and greeting cards to wish your loved ones "joyeux anniversaire."

Drop in for breakfast at Leney's, a modest, clean restaurant where, should you desire, "Ici on parle français." You notice that the waitress addresses many customers by name while they appear to know one another. After having savored delicacies that would satisfy the appetite of a lumberjack, you walk it off by strolling through a park that honors le Général Lafayette.

You come upon the statue of Ferdinand Gagnon, a local journalist who, according to the inscription on his monument, founded *La Voix du Peuple* in 1869. Suddenly, the sweet aroma of pipe tobacco draws you elsewhere in the park, where a few elderly gentlemen enjoy chatting about *la politique* and *les*

Franco-American Life and Culture in Manchester, New Hampshire

Aerial view of Notre-Dame, including the Flat Iron district and former Amoskeag mills, late 1950s. *Photo by George L. Durette, courtesy of Dick Duckoff.*

sports. They might even invite you to join in the discussion if they realize that you speak their language.

The setting could be a city in la Normandie, France, or perhaps a village in la Gaspésie, Québec. In reality, you've just experienced a tiny slice of Franco-American life and culture in one of New England's best preserved "Petits Canadas," the Notre-Dame section of Manchester's West Side.

I grew up in a mixed neighborhood on the East Side, where we were the "French family" living in between families of Scottish and Greek origin, not to mention Yankees, the Polish and the Irish across the street. But I had always wanted to live on the West Side, in the Little Canada of my birthplace. In 1981, at age thirty, I married Claudette Ouellette, the only Franco-American of my generation who introduced me to her mother in French. Together, we moved to the West Side.

For Claudette, this was a *recommencement*, in somewhat more comfortable surroundings, of the life she had known as a child growing up in Notre-Dame's poorest area, the Flat Iron district. As for myself, the past few years have been a sociological experience. And, for our young son Charles, the

Vivre la Différence

West Side provides an atmosphere where he can benefit from his bilingual and bicultural heritage.

While accepting their transition from a rural society to that of urban industry, the Québécois insisted on preserving their Roman Catholic faith, their French mother tongue and their cultural traditions. This strong sense of religious and ethnic *survivance* has flowed through their veins since the eighteenth century, when the British conquerors of New France first attempted to impose upon them the Protestant faith and the English language.

In New England, this spirit of *survivance* resulted in the creation of isolated Little Canadas containing a network of religious, educational, social, cultural and commercial institutions. These enabled Québécois immigrants and their Franco-American descendants to function in French in nearly every aspect of life. Unlike European immigrants, who lived an ocean apart from their old country, the Québécois were a daylong train ride away from their native cities and villages. Using the railroad as an umbilical cord to their motherland, they visited relatives and friends, thus strengthening and renewing themselves

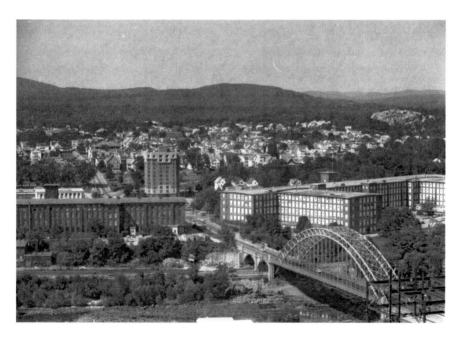

Seen here in 1987, our beloved green-arched Notre Dame Bridge (1937–89) served as the gateway to Manchester's Franco-American West Side. *Photo by Robert B. Perreault.*

In Notre-Dame and throughout Manchester, French-name business signs were still common in 1987. Many still exist, but many have disappeared. *Photo by Robert B. Perreault.*

culturally. These trips to Québec, coupled with the notions of *survivance* and life in a Little Canada, all aided Franco-Americans in maintaining their ethnic traits for a longer period and to a greater degree than most immigrant groups.

In few other places can you find more evidence of this than on Manchester's West Side. When visiting the Queen City's Petit Canada, you immediately sense that it differs from mainstream USA: the Notre Dame Bridge, currently the object of a historic preservation debate; the Train de la Reconnaissance Française (French Gratitude Train, often called "Merci Boxcar"); the Nazaire Biron Bridge; Pinardville; everywhere, Gallic-sounding landmarks abound. While it lacks the strong, outwardly colorful ethnic flavor of Boston's Italian North End or San Francisco's Chinatown, the West Side reflects the more subtle and private culture of its Franco-American inhabitants.

Several street signs recall over 450 years of French history in North America, beginning with Cartier Street, which commemorates Jacques Cartier's arrival in New France in 1534. Storefronts and residential mailboxes bear names that hail from the land of red wine and Sainte Jeanne d'Arc to that of Louis Riel and maple syrup. Judging by the number of front-yard grottos

Vivre la Différence

that feature a statue of *le Sacré Coeur* (the Sacred Heart), *la Sainte Vierge* (the Blessed Virgin) or some other celestial personage, you conclude that religious fervor must surely flourish in this neighborhood.

The Notre-Dame area's most awe-inspiring attraction, by far, is the church of Sainte-Marie. Looking across the Merrimack River from downtown, preferably at sunset, it's difficult to imagine the western skyline without that

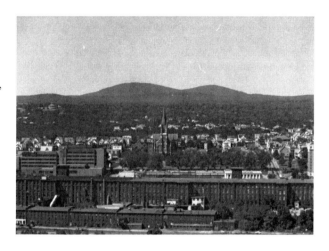

Right: Looking west from downtown Manchester toward Sainte-Marie's Church and the Uncanoonuc Mountains, 1987. *Photo by Robert B. Perreault.*

Below: The view from atop Rock Rimmon, 1987, evokes memories of a Québécois village with the church as the nucleus of people's lives. *Photo by Robert B. Perreault.*

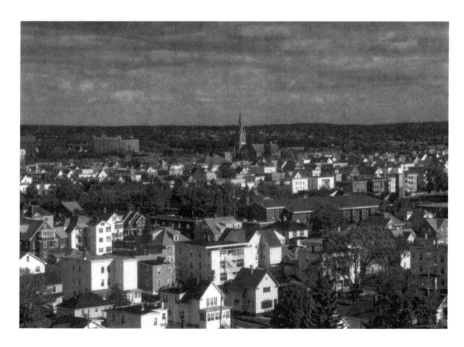

familiar spire set off by the Uncanoonuc Mountains gently reposing in the distance. Or, with a bird's-eye view from the summit of Rock Rimmon, you gaze upon Sainte-Marie's as it towers like a guiding force over the rooftops of its parishioners' homes. In a way, the scene resembles an old Québécois hamlet, with the church as its nucleus, thus reflecting an era when the lives of its *habitants* revolved almost exclusively around their faith.

Sainte-Marie's is an example of exquisite artistic achievement that evokes, in smaller form, all the splendor of Europe's finest Gothic cathedrals. Moreover, the church memorializes and symbolizes the enormous sacrifices and religious zeal of its earliest parishioners. Many lived in overcrowded tenements and spent long hours toiling in dark, noisy, humid textile mills and shoe factories for wages that barely paid the rent.

The West Side's less fortunate Franco-Americans resided in tenements and rooming houses of Notre-Dame's main commercial district. The Flat Iron was a pennant-shaped area located, as older Franco-Americans say, "*en bas d'la côte*" (at the bottom of the hill), between Sainte-Marie's Church and part of the Amoskeag Millyard's West Side portion.

The Flat Iron had an ambiance and a way of life all its own. Its labyrinthine streets and alleys were lined with massive wooden or brick buildings, some stretching a block long, with three or four stories and flat roofs. At street level, businesses of every type—from grocery stores to restaurants and bars, from clothing and shoe stores to barbershops and beauty salons—were owned and operated primarily by middle-class Franco-Americans. For a few years during the 1930s, these merchants, along with others scattered

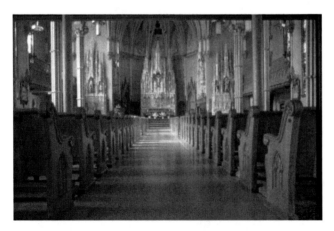

The interior of Sainte-Marie's Church, 1985. Although changes have occurred over the years, essentially the church has preserved its original flavor. *Photo by Robert B. Perreault.*

Vivre la Différence

about Little Canada, published their own neighborhood newspaper, *L'Écho de Notre-Dame*. In this way, they encouraged area residents to patronize only the West Side businesses of their compatriots to avoid sending their hard-earned, Depression-era dollars across the river to downtown Manchester.

The upper floors of the Flat Iron's business blocks included single rooms or apartments with those familiar, never-ending rear porches displaying jungles of freshly laundered clothing. Despite their apparent lack of material wealth, most Flat Iron residents were proud and meticulously clean. Perhaps a bit far-fetched by today's standards, it was not uncommon for an early twentieth-century Franco-American woman to work a fifty-four-hour week in the mills while finding time to care for the family and wash the cupboards, woodwork and floors a few times per month. My wife, Claudette, enjoys retelling stories about her maternal grandmother, Marie Leclerc-Lesmerises, who used to follow her husband, Albert, around their Flat Iron apartment with a dustpan to catch falling ashes from his cigar.

Because of the Flat Iron's closely knit structure, everyone knew everyone. Yet, according to Claudette, they respected one another's privacy. However, in order to survive, you had to be tough. Under certain circumstances

McGregor and Marion Streets in the Flat Iron district with tenements and the Walter Parker Wading Pool, late 1950s. *Photo by Albert G. Boutin.*

The author's future wife and mother-in-law, Claudette and Gilberte Ouellette, Somerset Street, Flat Iron district, 1955. Present site of CMC's emergency-room parking lot. *Photo by Arthur Ouellette.*

things could get rowdy, especially on hot summer nights when local bars and cafés remained open late. Several merry old souls, having imbibed to excess, might come waltzing along an all-too-narrow sidewalk singing *"Prendre un p'tit coup c'est agréable"* (downing a little shot feels great). The combination of the heat, the congestion and the free-flowing liquor sometimes led to family squabbles or back-alley brawls whose harsh sounds and earthy Franco-American *jurons*—swearwords evoking God, every saint in heaven or all the sacred vessels in the sacristy—reached the innocent ears of otherwise sleeping children. They, in turn, tended to grow up well before their time.

During the mid-1960s, urban renewal wiped the Flat Iron district away, replacing it with modern commercial structures and large parking lots. While staring out at this wide-open space today, you would find it difficult to imagine what once stood there. The memory of what went on in the tenements, stores, bars, streets and alleys lives on in the hearts of those who once called this area home, a home replaced by asphalt and painted lines indicating precisely where and where not to park your car.

Among the West Side's newer buildings is Saint Mary's Bank, known to its Francophone depositors as La Caisse Populaire Sainte-Marie. The business world owes a debt of gratitude to a humble but astute parish priest,

Vivre la Différence

Monsignor Pierre Hévey, second pastor of Sainte-Marie's and a pioneer builder in both Lewiston, Maine, and Manchester. By inviting Alphonse Desjardins, founder of Québec's *caisse populaire* (credit union) system, to Manchester in 1908, Monsignor Hévey initiated proceedings that led to the establishment of the first credit union in the United States. Beginning modestly in the Notre Dame Avenue apartment of its first president, Attorney Joseph Boivin, La Caisse Populaire Sainte-Marie inspired the creation of similar organizations throughout the country and has itself grown into a multimillion-dollar financial institution. Up to 1984, its annual stockholders' meetings were conducted entirely in French. For practical reasons the following year, directors introduced the English language into these reunions, while retaining French in the prayer and in opening remarks. Saint Mary's Bank employs several bilingual tellers to serve its Franco-American clientele.

One of the West Side's unique features is the Train de la Reconnaissance Française, an old military forty-and-eight boxcar capable of carrying forty soldiers or eight horses. Located in Monseigneur Napoléon Gilbert Park on Reed Street south of Bremer, the boxcar was one of forty-nine donated by the French government in 1949 to each of the forty-eight states as well

Birthplace in 1908 of our nation's first credit union, Attorney Boivin's Notre Dame Avenue home, 1987. Presently the site of America's Credit Union Museum. *Photo by Robert B. Perreault.*

as one shared by the District of Columbia and the territory of Hawaii. It contained art treasures and gifts for the American people in recognition of their generosity toward war-torn France after 1945.

For many of the West Side's elderly or longtime residents—some of whom knew one another in Québec prior to their migration—the old neighborhood has provided an ambiance of comfort, stability and a sense of belonging to one large French Catholic family. Often, people resided on the same street or even occupied the same house or apartment for generations. Most working-class families lived, and still live, in closely crowded double- and triple-decker homes built around the turn of the century by the habile hands of Québécois and Franco-American carpenters, who have a reputation for fine craftsmanship.

Inside, the large kitchen resembles those in old Québécois farmhouses. Here, people not only cooked and ate but actually lived on a daily basis, while reserving their tiny parlor for Sunday's *grande visite* (important visitors). Even in some of today's households, life in *la cuisine* has become so engrained that hosts find it difficult to usher their guests into the living room. Everyone seems glued around the kitchen table or tied to nearby rocking chairs.

Our former upstairs neighbor, Violette Leclerc (see "Quintessential West Sider of Yesteryear"), who died in 1985 at age ninety, typified those who have seasoned the West Side with their ethnic flavor. My main reason for moving to Little Canada was to become acquainted with men and women of Violette's generation, who are disappearing gradually, taking with them an irreplaceable piece of the Franco-American experience. Claudette and I often visited Violette to hear her tell her stories.

A proud and deeply religious woman, Violette attended daily Mass in French, wearing her Sunday best. She belonged to several parochial societies and contributed toward a small stained-glass window in Sainte-Marie's Church that bears her name. Although she understood English and spoke it with a marked Québécois accent, she preferred French, always complimenting those younger than she who also spoke it well. She read avidly, only the best and morally acceptable works of French, Québécois and New England Franco-American literature. She also wrote poetry and recorded all major family events in her journal. Her personality and mannerisms reflected an old-world *gentillesse* and *politesse* that seem so rare today. Regardless of your age or how long she might have known you, she would always address you as "monsieur," "madame" or "mademoiselle."

Vivre la Différence

Despite these formalities, Violette was a warm, loving, generous soul filled with Franco-American joie de vivre. She enjoyed reminiscing about her childhood in Québec. But she would let you know that she took great pride in her U.S. citizenship, never failing to express her opinions—staunchly Democratic—both in person and at the ballot box.

At eighty-eight, Violette's final, self-imposed task before leaving her apartment of forty years consisted of washing everything from floor to ceiling to enable her landlord to show the place without fear of embarrassment.

Considering today's fast pace and ever-accelerating rate of change, it's a miracle that Manchester's West Side has preserved as much of its original character. Yet, in her old age, Violette and her contemporaries witnessed the birth of Little Canada's belated entry into a state of transition between past and future, a few aspects of which saddened her.

Gone are most parents who once insisted that French be spoken in the home so as to ensure its continued use. Gone is the Franco-American parochial school system, with its half-day of French, half-day of English that gave students a bilingual and bicultural perspective on society. However, Violette was disturbed mostly by what she perceived to be the first hints of erosion in that sense of place that made the West Side so special in the eyes of its inhabitants.

New Hampshire's phenomenal growth in recent years has begun to affect Manchester's once isolated Little Canada. To some, this has meant prosperity and a better way of life. To others, especially the poor and the elderly, it has become a socioeconomic nightmare.

According to West Side tradition, whenever a Franco-American homeowner died, his or her children kept the house. There, they raised their offspring while continuing to rent its other apartments at a modest rate. Today, however, the skyrocketing value of real estate has caused many heirs to sell their deceased parents' home in exchange for a handsome profit. Often, outsiders to the neighborhood—at times, even out-of-towners or out-of-staters—purchase such properties solely for investment purposes. With a hefty mortgage and no rent-control laws, new landlords can, overnight, increase rents by half or more. This forces many longtime tenants with only low or middle incomes out of their homes. The profitable turnover of a property can occur every few years. And with each turnover comes another rent increase.

Since gentrification has not come to Manchester's West Side, many of Little Canada's more expensive apartments are being rented by two or

more single, unrelated individuals who share living expenses. These include newcomers to the neighborhood or to the city, people who have little in common with other recent arrivals and much less with the West Side's older residents. Consequently, it becomes difficult to know one's neighbors.

Thanks to a mutual respect of personal rights and of privacy among most newcomers and longtime inhabitants, general harmony continues to reign. The area has seen an increase in negative behavior, however, from mild social discomforts such as littering, loud music and the inconsiderate blocking of driveways and alleys by loitering gangs of youths to such blatant crimes as vandalism, burglaries, open drug dealing and assaults. Granted, these phenomena are far from unique to Manchester's West Side. But in the conservative climate of a Petit Canada, where traditional ideas and customs die hard, any change must pass the test of time before it gains acceptance.

Time, therefore, is the key. With time, attitudes will evolve, newcomers will eventually blend with older residents to create a fresh, new neighborhood image, stability will return and the West Side of Manchester will once again find its sense of place.

As for the future of Franco-American life on the West Side, many questions remain unanswered. In the 1880s, skeptics predicted that the French language and Franco-American culture in New England would all but disappear within twenty-five years. Today, four times twenty-five years later, this prophecy has yet to be completely fulfilled. Moreover, owing to the recent renaissance of interest among most ethnic groups, it appears that Franco-American life, albeit in a more modern form, will continue to thrive.

For the time being, Claudette and I intend to remain in Manchester's Little Canada. We will continue visiting relatives and friends in Québec several times a year. And we will nurture the bilingual and bicultural ambiance that characterizes our home, not to mention our travels. With hope, our son will appreciate the cultural legacy that our ancestors have bestowed upon us after four centuries on North American soil. Therein lies the future of the Franco-American experience.

Author's note: Since the publication of this essay in 1987, the Franco-American West Side has continued to evolve into a more mainstream neighborhood with a controversial name, "Rimmon Heights," which the City of Manchester recently imposed upon it and which many citizens, especially longtime or former residents who grew up there, refuse to accept. Meanwhile, my family moved to another West Side neighborhood when we purchased a house in 1992.

QUINTESSENTIAL WEST SIDER OF YESTERYEAR

Stepping across the threshold into Violette Leclerc's apartment was like turning back the clock by several decades: everywhere, dark, turn-of-the-century molding, wainscoting, doors and cupboards; layer upon layer of wallpaper most recently painted over in a shade of deep pink; antique chairs, tables, dishes, lamps and other furnishings, all in pristine condition; a claw-foot bathtub; an old Florence cast-iron stove; a wooden crucifix dating back to World War I. And the list goes on.

This atmosphere is now but a memory. Earlier this month its creator, now in her eighty-ninth year, left her Franco-American West Side neighborhood, where she's lived for more than seventy years, to enter an East Side nursing home.

Violette is one among thousands of Québécois immigrants and their Franco-American descendants who brought the faith, language and traditions of their forebears that gave Manchester's West Side its ethnic flavor. Consequently, whenever a member of Violette's generation moves away or passes on, the West Side loses another small but important part of its old French character.

"The West Side isn't at all the way it used to be in my day," Violette said. "Back then, all we heard at home, at church, in neighborhood stores and on the street was French, spoken by old and young alike. Everyone knew everyone else, and we were like a big family because we all came from Canada. Today, I often feel alone, not because I don't have any relatives or friends—I have lots of those—but because I'm one of the only ones left from

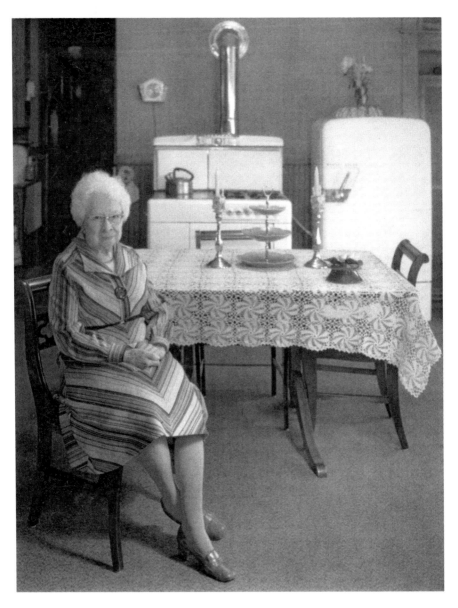

Violette Leclerc in her kitchen, 1983, shortly before she vacated her Cartier Street apartment of forty years to enter a nursing home. *Photo by Gary Samson.*

Vivre la Différence

those days. It makes me sad to see how today's young Franco-Americans can't speak French and don't know anything about their ancestors."

During the months that preceded her move, Violette spent many hours pondering her situation. She wondered if it were possible for her to live happily outside of her familiar environment. As she sorted through the numerous possessions she'd accumulated during her long life to decide upon what to keep, give, sell or dispose of, she began reminiscing, reliving her life's experiences.

The sixth of twelve children born to Michel and Delvina Grenier Leclerc, Violette first saw the light of day by the banks of the Rivière Chaudière in Sainte-Marie-de-Beauce, Québec, on February 9, 1895. Of the twelve, six died in infancy, including two sets of male twins.

As a master carpenter, Michel Leclerc offered his family a better life than did many other residents of Sainte-Marie, who were mostly poor *habitants*. He owned two houses, one for his family and the other that he rented as a grocery store with an upstairs apartment.

In winter, Michel Leclerc usually followed his compatriots to lumber camps in and around Jackman, Maine. Besides his ability to swing an axe, he acquired a reputation as an unbeatable arm wrestler. Despite being in Jackman, he always managed to come home for the holidays. "I remember the beautiful red sleigh my father built. Each year, after Midnight Mass, someone dressed as *le Père Noël* would arrive at our house in that sleigh. He always carried a huge bag full of gifts for our Christmas stockings: apples, oranges, candy, dolls and a few pennies, all for the girls; for the boys, there would be an assortment of wooden toys all built by my father. After opening our gifts, we'd have a *réveillon* (midnight supper) with *tourtières* and *cretons* (meat pies and meat spread), head cheese, sausages, all sorts of cheeses, pies, cakes, wine for the women, eau-de-vie (hard liquor) for the men. My grandfather was quite a fiddler. He danced like a marionette. There was music, singing and dancing till dawn."

In early spring, Violette's father returned from Jackman, since the owner of a maple grove near Sainte-Marie needed someone to take charge of his annual harvest. Having overseen the collecting of sap, he involved his children in the pleasurable aspects of maple sugaring. "He'd hitch our horse up to the red sleigh and take us into the countryside, where there was still a lot of snow, and we'd spend the day at the *cabane à sucre* (maple sugar house). There, we'd see how they turned sap into maple syrup. We'd pour hot syrup

onto the snow to make *tire* (pronounced "tseer," maple taffy), a real treat. My father molded things out of maple sugar: a small cabin or a prayer book with a bas-relief of a chalice on the cover. He won prizes for some of these, and on Sunday mornings, people gathered on the church steps and talked about my father's maple syrup and maple sugar. They said that his were the best tasting in the entire region."

Violette has fond memories of her mother, who, besides caring for six children, undertook numerous chores such as collecting eggs from the henhouse, tending the garden and making clothes. "My mother was an excellent seamstress. She made all of our clothes. And she always found time to help others. Her specialty was helping new mothers recover from childbirth. In those days it wasn't at all like today. Women had to stay in bed and not move for at least nine days."

Perhaps the most colorful member of Violette's family was her maternal grandmother, Rose de Lima Vachon Grenier, whose relatives founded Québec's Vachon pastry enterprise. While most Québécois descend from seventeenth-century French immigrants, Violette proudly spoke of her grandmother, who came from the Province of Brittany, France, during the nineteenth century. "Even though she came to Canada as a young girl, my grandmother always clung to the ways of her homeland, and Brittany was not like the rest of France. It had its own language and its own customs. Sometimes, we had a hard time understanding my grandmother because she spoke a mixture of Breton and French. And she continued to wear the native costume of her village. Each village in Brittany had its own costume, which included a *coiffe* (headdress) and an apron. Dressed like that, she stood out in Sainte-Marie. When she died she was laid out in her native costume."

Because, in the late nineteenth and early twentieth centuries, Sainte-Marie-de-Beauce had neither a doctor nor an undertaker, Violette's grandmother, a multitalented woman, rendered unique services to her fellow villagers. "When I was young, there were still a few Indian tribes living along the Rivière Chaudière. My grandmother learned a lot from them. They'd come around selling herbs, roots and flowers. My grandmother bought these and made medicines and potions that could cure just about anything. Sometimes she had some old wives' cures, like the one to stop a pregnant woman from having a miscarriage. If a woman started hemorrhaging, my grandmother would go down into the woman's cellar and collect all the spider webs she could find. Then, she'd place this little ball of webs in one of the woman's

Vivre la Différence

hands, and before you knew it, the bleeding would stop. It was strange. But she was really smart. She delivered eleven of my mother's twelve children. By the time the youngest was born, we had a village doctor."

Often, Violette's grandmother was called upon to shroud the dead, a task she and other family members took in stride. "As children, we weren't at all afraid of death because our grandmother often talked to us about how she washed and dressed the dead for their wake. To us, death was just another part of life."

Violette attended her village's convent school for girls, under the direction of the Soeurs de la Congrégation de Notre-Dame. One day, before having completed her elementary course, Violette, accompanied by her older sister, Marie-Anne, saw a group of young women who were visiting their hometown after having left to go work in New England. Violette and Marie-Anne were so impressed by the women's factory-made dresses and hats with large plumes that they immediately ran home. "We told our father about what we'd just seen and that we wanted to go to the States and work in the mills and earn lots of money so we could buy expensive hats with plumes. My father was quick with an answer: 'If you think for one minute that I'm going to let my daughters run off alone to go work in that Protestant country, well I have news for you girls.' Eventually, though, the whole family moved to the States. We thought we'd stay a few years and go back to Sainte-Marie. We ended up staying for good."

It was May 1909. Since the Leclercs already had relatives in Manchester, the Normand family, founders and proprietors of Normand Brothers' Bakery on Laval Street, they chose the Queen City as their adoptive home. Violette recalled her first impressions of Manchester: "I remember being so shocked and depressed when we got off the train at the old depot. We had taken a night train, and now it was early morning. The streets were filled with hundreds of mill hands on their way to work. Some of the women wore these dark veils, while others walked barefoot. They all looked so sad and poor. Where were the ones with the plumes? With time, though, we got used to it, and Manchester became home to us."

With the help of one of their cousins, Georges Normand, the Leclercs found an apartment in the Webster Block on Elm Street. The next day Violette, who was fourteen, and her other working-age siblings obtained employment in the textile industry. At first, Violette worked in the Stark Mills, after which she transferred to the Amoskeag Manufacturing Company, where she performed a variety of functions: spinning, weaving, drawing-in

and spooling. Since she and her sister Marie-Anne always managed to find jobs in the same workroom, they gave each other constant moral support, which rendered their mill experience more tolerable, though Violette admitted that she never really adapted to this type of labor. Meanwhile, Michel Leclerc easily found work as a carpenter, owing to the Québécois' reputation as excellent laborers in this field.

Accustomed to living in their own home in a quiet town, the Leclercs soon grew weary of their tiny, cramped apartment in downtown Manchester. Before long, they moved to the West Side, where the Normands offered them larger quarters in a more tranquil area. Within a few years, Michel Leclerc again became a proprietor, having purchased a house on Dubuque Street in Notre-Dame. There, in the heart of Sainte-Marie's Parish, which evoked pleasant reminders of Sainte-Marie-de-Beauce, the Leclercs found comfort, living among their fellow Québécois and Franco-Americans.

Their finances having improved, the Leclercs next faced emotional hardships. "It was a hot day in June 1915. My sister and I were working at the Amoskeag when suddenly someone came to tell us that our father was at L'Hôpital Notre-Dame-de-Lourdes. They were building a house on Kearsarge Street and my father fell from some defective scaffolding at 9:30 in the morning. We rushed to the hospital. Poor Papa. At noon, while the Angelus bells were ringing at Sainte-Marie's, our father passed away. He was only fifty-eight. I'm sure he went straight to heaven."

Although 1918 brought an end to World War I, that year, Violette knew anything but peace. Before U.S. involvement in the war, she'd become engaged. Afterward, she discovered that her fiancé had returned from the war a changed man. "I don't know if it was the war that shook him up or what, but when he came back from Europe, he was drinking quite a lot, something I'd never seen him do before. I told him that he'd better make his choice: it was either me or the bottle. Well, he made his choice and I made mine. I never married—not that I never got any offers, mind you. I'd had it. One man was enough."

That same year brought another deadly force: the 1918 influenza epidemic. Again, Violette's faith was tested. "Since, at the time, I was one of the few who didn't have the flu, I was taking care of my brother, Alonzo, and his wife, Édouardina, who both had it. Édouardina was six months pregnant. That flu, when it hit, it hit fast. Everywhere, people were dropping like flies. One

Vivre la Différence

morning, I saw Édouardina die. The doctor, who was also there, decided to try and save her baby, taking it out by Caesarean section. It was a baby boy. I held him in my arms, and we baptized him right away. He lived for only fifteen minutes. The doctor then turned to me and said: 'The only place for this baby is with his mother; he belongs with his mother.' The doctor put the baby back inside of his mother's womb and sewed her up. Now, they would be together forever. Five hours later, my brother joined his wife and son. Imagine, I saw three of my family members pass away in a matter of hours. When I think of those two big coffins all draped in black being taken out of the house for the funeral, it makes me shiver, even today in 1983."

The great strike of 1922 at Amoskeag put an abrupt end to Violette's career as a textile hand, though cloth would always remain a part of her livelihood. Neither keen on millwork nor involved with strike activities, Violette left Amoskeag, as did Marie-Anne. Since both had learned sewing from their mother and from the nuns back home, and since both possessed dressmaking and tailoring skills, they became seamstresses.

For forty-odd years, while working at women's apparel stores—Pariseau's, Melbry's and Beauregard's—the Leclerc sisters, also known as the "French girls," earned the admiration and respect of customers for the fine quality of their work.

In 1934, Violette lost her mother. In 1943, when the surviving Leclerc children sold the family home on Dubuque Street, Violette and Marie-Anne took an apartment on Cartier Street, the one Violette recently vacated. After the death of Marie-Anne in 1970, Violette lived alone.

Always full of life, energy and humor, Violette never let age and retirement prevent her from accomplishing her goals. She continued to sew for relatives and friends. She also included, among her many pastimes, a lifelong love of literature, both reading and writing. Although she never tried to publish her writings, preferring to enjoy them privately or with those close to her, she nevertheless used a pen name, "Violette des Champs" (Violet of the Fields), which reflected her attachment to nature. Her latest creation is a poem about some trees outside her nursing-home window.

Violette Leclerc might reminisce now and then, but her primary thoughts are of today and tomorrow. She still has a lot of living to do. Perhaps her only regret in life is that she never bought a plumed hat.

Perhaps for her next birthday…

WORKING WITH HIS HANDS
THE FRANCO-AMERICAN WAY

On a blistering summer day in 1903, a mother wheels her ten-month-old son along a street in Danielson, Connecticut. Suddenly, the afternoon sun's scorching rays descend upon the baby's tender skin, as the parasol attached to his carriage falls. Surprised, the mother picks it up and returns it to its proper position. Several minutes and a few blocks later, again, down it comes. Baffled, the woman carefully replaces it and moves on. While pausing at an intersection, she notices the parasol wobbling. On bending over, she observes a tiny pink hand unscrewing a nut that keeps the parasol in place.

Not yet a year old, the child is already expressing, in his own little manner, his interest in the world of nuts, bolts, screws and whatever they hold together. One day, this world would become his livelihood as well as his passion.

Henry Louis Perreault was born on October 17, 1902, in Danielson, Connecticut. The eldest of six children—one of whom, Charles, died in infancy—of Joseph Perreault, a native of the Worcester area, and of Éliza L'Heureux, a farm girl from Saint-Simon-de-Bagot, Québec, Henry grew up in an atmosphere wherein machines had become a family tradition. His grandfather, François Perreault, who was born in 1849 to one of the earliest Franco-American families in Webster, Massachusetts, was a machinist. Today, Henry cherishes several tools his grandfather made in the 1880s in the machine shop of one of various factories in which he labored.

Besides caring for horses in a livery stable and driving and maintaining horse-drawn hearses and coaches for a Danielson undertaker, Henry's father spent several years in textile mills, first as a weaver and then as a loom fixer.

As a boy, Henry acquired knowledge by watching an uncle make him various toys. He also learned by building things with one of the earliest erector sets.

In school, Henry's forte, arithmetic, sometimes put him in conflict with his teachers. "At Saint James School, they started teaching us algebra in the seventh or eighth grade. The nun gave us long, complicated ways of solving problems, and she expected us to do it by the book. I was pretty good at doping out problems like that, so I'd always figure out some shortcut and I'd still come out with the right answer. Then, the nun would say it was wrong because I hadn't done it *her* way. What difference did it make to her how I came up with the answer, as long as I understood the problem?"

During his adolescence, Henry had many opportunities to acquaint himself with different types of machines. At thirteen, he worked for nearly an entire summer as a spooler in a textile mill—that is, until a child-labor inspector declared him underage. Beginning at fourteen, he spent his summers with his father in a factory that produced fabric for tires.

In 1916, Joseph Perreault purchased a used 1915 Model T Ford. Henry viewed it as a challenge to his quest for a greater understanding of machines and their inner workings. Too young to obtain his driver's license, he liked to, as he says, "monkey with" the Model T. Soon, he knew more about tuning it up and keeping it running than did his father.

Henry's interest in science led him to collaborate with a friend in assembling and selling wireless telegraph sets. He learned the Morse code for sending and receiving messages at home. During World War I, however, the U.S. Armed Forces obliged amateur communications enthusiasts to take down their antennas to prevent them from intercepting military radio transmissions.

Henry's fascination with radios eventually helped him begin his lifelong career. Upon graduating from Killingly High School in 1920, he and a classmate secured interviews with the owner of the *Windham County Transcript*, who sought to hire one apprentice typesetter. Besides demonstrating an aptitude for mechanics, Henry also captured the newspaperman's attention with his knowledge of radios, a hobby common to both. Consequently, Henry was hired over his competitor—to the surprise of their former typing teacher. "I did all right in high school, in just about every subject except typing. It's the only subject I ever flunked in my four years. I had good speed, but my accuracy wasn't that good. When my typing teacher found out that *I* was the

Vivre la Différence

one they'd hired over at the *Transcript*, she remembered how lousy I'd been typing, and all she could say was, 'Oh my God.'"

Before Henry began working, his employer sent him to Brooklyn, New York, where he spent six weeks at the Mergenthaler Linotype Company's factory school, learning to operate and repair Linotypes. To a young man who had barely ventured beyond the boundaries of Danielson, New York offered fascinating discoveries. Among Henry's most memorable recollections is a concert in Central Park given by the March King himself, John Philip Sousa.

Having completed his course, Henry returned to Danielson and began his five-year apprenticeship at the *Transcript*. Besides his duties as a Linotype operator and machinist, he occasionally set type the old-fashioned way—by hand, one character at a time. For a fifty-five-hour week, he earned twenty dollars, plus frequent overtime pay.

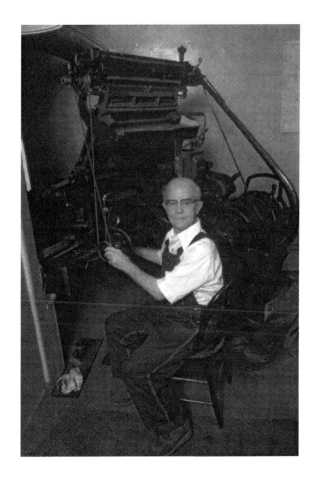

Henry Perreault came out of retirement for a day in March 1984 to repair a Linotype at Queen City Press. *Photo by Robert B. Perreault.*

The Perreaults were fortunate that their eldest had found work during the summer of 1920, because the following spring, Joseph Perreault succumbed to tuberculosis at age forty. Eighteen-year-old Henry aided his widowed mother by becoming father and breadwinner to his four siblings, aged two to twelve.

Eventually, Henry's salary rose to thirty dollars per week. But when his apprenticeship came to an end in 1925, his employer trimmed the budget by hiring a new apprentice. Because Danielson offered no other job opportunities in his field, Henry searched elsewhere. "I looked in Providence, in Worcester, at the Rumford Press in Concord. No luck. One of my aunts had lived in Manchester before coming back to Connecticut. She had nothing but good things to say about Manchester. So, I decided to come here. I finally found a job at the Clarke Press on Franklin Street, where they needed a Linotype operator. At first I lived in a rooming house on Hanover Street, right next to the funeral home, Letendre's, but when the rest of the family came, we moved to Merrimack Street. What a time that was. In those days, going from Danielson to Manchester was an all-day affair, and to make things worse, the truck we'd hired to move our furniture broke down. We had to send for another truck and transfer everything from one to the other. I'll never forget that day."

So seriously did Henry fulfill his role as head of the Perreault family that, when they first appeared in the *Manchester Directory* in 1926, he and his mother were erroneously listed as husband and wife.

During the Depression, unlike most people, Henry and his kin fared well, due to the stability in the typographical and printing business. Soon, Henry became shop foreman, which enabled him to purchase better-than-average touring cars for taking his mother and siblings on Sunday drives. Moreover, he could now afford to rent a single-family house on Buzzell Street.

In 1936, due to a strike at the Clarke Press, Henry became a Linotype machinist for the Union Leader Corporation. At the outbreak of World War II, he tried to enlist in the U.S. Armed Forces but failed the physical examination. Nonetheless, the family paid the ultimate price. Arthur Perreault, the elder of Henry's two younger brothers, was lost in action due to a bombing attack against the USS *Franklin* in 1945.

Well into his forties and having raised his siblings to adulthood, Henry envisioned the future, dreaming of starting his own family. In 1949, he met

Vivre la Différence

Madeleine Robert, thirteen years his junior. Despite their mutual attraction, certain obstacles surfaced, as Madeleine recalls. "On Sundays I used to see this man in church, and sometimes we'd run into each other again while buying the Sunday paper at the market. I remember telling one of my girlfriends how this was just the kind of man I wanted to marry some day. The only problem with this one was that he was already married, or so I thought, because he was always at church with two young women, an elderly woman, and a young man. I took them to be two married couples with the mother of one of them. It's whenever I found out the truth—the couples were all brothers and sisters to each other, and the man I liked wasn't married after all."

That hurdle overcome, yet another, more challenging one presented itself. "My mother and father were pretty well off, and they wanted me to marry a doctor, a lawyer or someone like that, but a Linotype machinist? Of course I was over thirty, but even though I considered myself old enough to decide for myself, I still lived at home and still had to face my parents. Henry and I went out for a year before I finally told my parents about us. At first they were shocked, but after they'd met Henry and saw that he was a good man—not to mention that he was pretty handy around the house—they gave in."

At ages forty-seven and thirty-four respectively, Henry Perreault and Madeleine Robert were married in Saint-Georges Church on January 4, 1950, a day during which the mercury hit sixty degrees Fahrenheit. Shortly thereafter, they moved into their newly built Cape on Lowell Street. For the first time ever, Henry was a homeowner.

Within months of their wedding, Henry came close to death. While repairing a Linotype at the *Union Leader*, he got a sliver of lead in his finger, which caused an infection that subsequently turned into pneumonia. Having accompanied Henry in the ambulance, Madeleine witnessed a scene in his hospital room that will forever remain imprinted in her mind. "Since Henry had difficulty breathing, they put him in an oxygen tent. For some reason, the oxygen wasn't working. There was no time to lose. The doctors, the nurses, nobody there seemed to be able to get that oxygen to work. Then, all of a sudden, there's Henry, my poor husband, sticking his head out of the tent and playing around with the gadget to make the oxygen work. I couldn't believe my eyes. You know what? *He* fixed it himself. The guy was half dead and he fixed it himself and saved his own life. That's what I call a

real mechanic. Today I can sit back and laugh about it, but back then, while it was happening…"

Henry's dream of raising a second family produced two children, Robert and Louise. To make life more comfortable for all, he employed his knowledge of carpentry, electricity and plumbing to turn the attic and cellar into bedrooms and playrooms.

Having labored for over half a century, Henry retired in January 1973, three months after his seventieth birthday. It was a timely move. Soon, most Linotypes themselves would be retired—replaced by computerized methods of typesetting.

Today, at eighty-one, Henry takes pride in his new role as a grandfather, one which took him nearly eighty years to acquire. With Madeleine, he enjoys the comfort of a new home, where he does yard work or putters in his basement workshop.

One of a handful of Linotype machinists left in Manchester, Henry occasionally comes out of retirement to assist those rare printers who cling to their Linotypes. As long as there's one broken Linotype in Manchester, Henry will be around to fix it. That's what he knows best, the world of mechanics.

Author's note: After the publication of this article in April 1984, Henry Perreault lived on until 1990, to age eighty-seven and a half. Madeleine lived until 2000, to age eighty-five. Henry and Madeleine were my parents.

A NEW LIFE FOR AN OLD FAVORITE

The Innocent Victim

On January 2, 1975, I walked from my apartment at 166 Concord Street in Manchester to the Association Canado-Américaine building—now home to the Centre Franco-Américain—at 52 Concord Street. It was my first day as the society's librarian-archivist.

Upon my arrival, Monsignor Adrien Verrette, the library's chief benefactor, greeted me in French and explained my duties to me. He led me through the library's three rooms devoted, respectively, to French Canada, France and Franco-American communities throughout the United States. He also showed me an alcove of floor-to-ceiling file drawers filled with archival materials. At the time, he estimated the library's holdings at thirty-five thousand, including books, pamphlets, periodicals, newspapers, dissertations, manuscripts, scrapbooks, photographs and miscellaneous items.

Monsignor Verrette then recalled the library's humble origins and how its founder, Adélard Lambert, had nourished a voracious appetite for books by using his job as a door-to-door salesman for the E.M. Chase Tea Company in Manchester to obtain whatever reading materials he could buy from, trade with or be given by his fellow Québécois immigrant customers. By 1918, after more than two decades of collecting and several moves on both Manchester's East and West Sides, Lambert's apartment was bursting with what he himself calculated at four thousand volumes—among them rarities found nowhere else—for which he sought a more appropriate home. Local scholars and others from as far away as French Canada knocked at Lambert's door in search of that elusive tome or article. One of these was the writer

Reverend Henri Beaudé, better known as Henri d'Arles. As ACA chaplain, he persuaded the society's officers to purchase Lambert's collection.

Thus, on May 15, 1918, was born the ACA library, otherwise known as "La Collection Lambert." The library has since grown beyond anything that Lambert could have imagined.

On a wall near the desk at which I'd be working, Monsignor Verrette pointed to an oil painting of Adélard Lambert by Lorenzo de Nevers. The artist depicted Lambert standing before a set of bookshelves. Lambert is holding a biography of his childhood hero, Ferdinand Gagnon, father of the Franco-American press, while gazing up at Gagnon's portrait.

In this ambiance, with Lambert's portrait hanging above and his bibliothecal legacy surrounding me, I served what I consider my apprenticeship in the field of Franco-American culture. Little did I realize on that January morning that my daily walk to and from work over the next six and a half years would

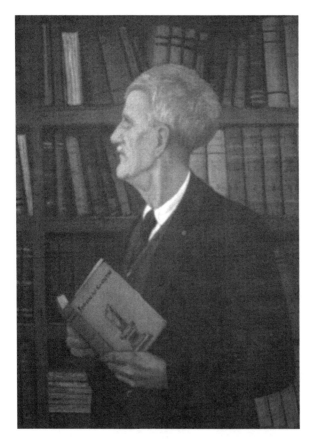

Detail of a larger portrait of Adélard Lambert holding Josaphat Benoit's 1940 reconstituted biography of Ferdinand Gagnon. *Oil painting by Lorenzo de Nevers.*

Vivre la Différence

not only take me into the world of Adélard Lambert himself but also past the site of an event that inspired him to write the original French-language version of *L'Innocente Victime*. But more about that later.

In his *Journal d'un bibliophile* (1927), Lambert relates how his job selling tea and coffee transformed him from avid reader with an average-sized home library to a serious collector with a mission to gather and preserve every French-language publication within reach.

It all began on a mild forenoon during the spring-cleaning season, about 1899. Everyone's doors and windows were open. Upon arriving at the home of one Madame René, Lambert froze, dumbfounded, on the threshold of the entrance to her kitchen. There, resting across two chairs in front of the stove, its fire crackling, was a large box measuring approximately two by three feet. It was filled with books. The moment he saw the woman's arm pull back from the box, a single book in hand, Lambert let out a cry. Madame René wanted to know what was the matter. He told her he surmised that she was about to throw the volume into the flames. With a laugh, she confirmed his suspicion: not only the one she was holding, but the entire boxful. When Lambert asked her if she would, instead, sell him the books, she looked surprised. She offered them for free, as he'd be doing her a favor by ridding her much faster of what she considered to be an encumbrance. Lambert seized the opportunity and gave the woman two dollars, which she accepted only at his insistence.

Later, during his lunch break, Lambert went through the box and counted 168 volumes of what he labeled "Canadiana," most in good condition, the rest salvable. Lambert goes on to describe the thrill of the search for and the discovery of a rare book, a missing issue in a collection of periodicals or even loose pages from a volume thought to have been lost and suddenly found. He writes that only a true bibliophile can appreciate such a feeling. Perhaps by literary osmosis, through my experience working—a better word might be *playing* because it proved to be so exciting—among his treasures, Lambert transmitted that *joie de découvrir* to me.

Among my discoveries, in addition to Lambert's own writings, was a pamphlet about him and some of the ACA library's prized possessions, entitled *Un Lettré Illettré: Étude sur Adélard Lambert, collectionneur et folkloriste* (1944). Its author was my maternal grandfather and former ACA president, Adolphe Robert, who had known Lambert personally and had overseen his

collection after the latter's return to his native Québec in 1921. Still, my most intriguing Lambert-related find was *L'Innocente Victime*.

Lambert published his novella as a *feuilleton*—a serial novel in a newspaper. Originally called *L'Innocente Victime: Épisode de l'Émigration des Canadiens-Français aux États-Unis*, it appeared in several issues of Ottawa's daily, *Le Droit*, during September 1936. Unlike his more fortunate colleagues, Lambert did not live to see his *feuilleton* printed in book form. In fact, the version I found in the ACA library—and have recently reexamined, thanks to ACA librarian Marie-Jeanne Chaput—is no more than the yellowed brittle newspaper clippings of the *feuilleton*'s text and illustrations cut and pasted onto sheets of paper, hand-paginated from one to thirty-nine and put together on the inside like a small homemade album but professionally bound in black leather on the outside to simulate a real book. The strange volume—one among many of its kind in the collection—also includes a reprint of the July–September 1931 issue of the *Journal of American Folk-Lore*, to which Lambert, an ardent collector of Québécois folk tales, often contributed. The title on its spine, all in gold, reads simply "A. Lambert. *Contes Populaires Canadiens*. 3–4."

Due to its fragile condition, I read Lambert's *feuilleton* in a single sitting. Hooked right from the prologue, I wanted it to go on and on.

Without giving away any secrets about this work of historical fiction whose plot-driven thread of mystery holds the story together, I can safely reveal a few of Lambert's sources of inspiration: the early era of the migration of Québec's rural population to New England's industrial cities and mill towns; and the participation—not always willingly—of Québécois farmers, loggers and general laborers in the Civil War.

Neither unusual nor earth-shattering material so far.

Another concern that many members of Lambert's generation shared, and which caused much debate, was the notion of return to the homeland or even not leaving Québec in the first place. Again, without spoiling anything for readers, I can give the moral of Lambert's story. It appears in the novella's last line: "*Mes petits enfants, c'est chez nous, dans notre pays qu'il faut rester.*" It was an admonition to stay home in one's own country.

But what gripped me most about *L'Innocente Victime* was another of Lambert's sources of inspiration, which comes well before the above-mentioned themes. The first sentence of the prologue reveals the setting and the time: Manchester in 1899. More precisely, October is approaching.

Vivre la Différence

Workers excavating the site of two recently demolished hovels have discovered the skeleton of a woman roughly thirty-five years old at the time of her death, whose body had lain there for an estimated twenty-five to thirty years. Further examination had determined that the woman had been murdered.

Who was this woman? And how and why had she come to such a violent end? These are questions for the average reader, to which Lambert provides answers. I, as a Franco-American from Manchester who was then custodian of La Collection Lambert, needed to know more.

Unbeknownst to me up to then, twice each day between my apartment and the ACA building, I had been walking past the so-called scene of the crime: the corner of Chestnut and Concord Streets. Lambert further piqued my interest by saying that, while the police investigation proved inconclusive, a character in the novella named Madame Caron, an elderly woman and longtime resident a block away on Vine Street, harbored suspicions about who the victim might have been. The ACA building and its parking lot sat on Concord Street on land adjacent to Vine Street. It seemed as if wherever I went in the neighborhood, everything had some connection to *L'Innocente Victime*. Indeed, Lambert had aroused my hometown historian's curiosity. Had he made it up about the woman's skeleton, or had he based his story on fact? I couldn't resist doing research to uncover the truth.

My initial look through the September and October 1899 issues of local newspapers, including Manchester's French-language daily, *L'Avenir National*, proved fruitless. I concluded that Lambert had either witnessed the demolition of those houses and had invented the story of the skeleton to add spice to his novella, or else the event had actually occurred but at some other time. Any date might have been a possibility—thus the search through newspapers would be for the proverbial needle in a haystack that perhaps didn't even exist. Despite my strong desire to know the facts, far more important matters required my attention.

Still, from time to time, I wondered about the story of the skeleton. I did so especially when, in the late 1970s, my friend Renaud Albert, an editor at the National Materials Development Center for French in Bedford, New Hampshire, began exploring the ACA library hoping to locate original editions of Franco-American novels in French. His project led to the publication of new editions of nearly a dozen such works, some of which

had been out of print for decades. Consequently, in 1980, *L'Innocente Victime* finally came out in book form. I have read and reread it many times since, always asking myself: What about that skeleton?

And then, after a few more decades, thanks to Margaret Langford's request that I write this foreword to her translation of *L'Innocente Victime*, I had no choice but to make one last attempt to solve Lambert's mystery. Again, I encountered the usual negative results—that is, until I called someone whom I should have thought to contact long ago: local historian John Jordan. John has spent many years perusing various Queen City newspapers on microfilm in the New Hampshire Room at Manchester's Carpenter Memorial Library. From the library's windows, one can gaze out at the corner of Chestnut and Concord Streets. If anyone knew anything, John would. Although he had never heard of *L'Innocente Victime*, the moment I mentioned the demolition of those old houses, John said, "You mean where they found a skeleton?"

Thanks to John, and with the collaboration of Cindy O'Neil and Mary Orzechowski of the Carpenter Memorial Library, I finally found my answer.

For whatever reason, Lambert changed the month of the real-life event that had sparked his story. Based on his declaration in the prologue that October was approaching, I had always limited my search to newspapers dating from September 1 through October 31, 1899. Had I begun looking just a few days earlier, I would have seen an article, entitled "Skeleton Found," on page one of the *Manchester Daily Mirror & American* dated August 28, and another less conspicuous item on page seven of the same newspaper's August 31 edition, entitled "Doctor Once Lived There."

The first article, published on the actual day of the discovery, reveals that the skeleton of a woman about eighteen years old was unearthed in what had been the dirt basement floor of a recently demolished house at 92 Concord Street, corner of Chestnut. Her skull had a split on one side, an indication of a possible crime, though the technology of the era could not determine whether the injury had been inflicted while the victim was alive or postmortem. Because the woman's burial predated the installation, directly above her remains, of a drainpipe manufactured in the early 1870s, any damage, including the split in her skull, could have occurred at that time. Clearly, her body had been buried there at least twenty-five years earlier, and perhaps well before that.

The second article states that the police investigation had ended inconclusively. If a murder had indeed taken place, time had erased any

Vivre la Différence

incriminating evidence. Coincidentally, the coroner on the case, Harrison D. Lord, told a *Mirror* reporter that as early as 1844, his father's family had occupied the east half of the house in question, while a Doctor J.S. Calef, the building's proprietor, had lived in the west half. Harrison speculated that Doctor Calef might have owned the skeleton as part of his medical practice and had buried it in the basement when it no longer served his purposes.

Subsequently, in addition to apartments, the building housed businesses, including a saloon. The newspaper implies the possibility of a murder with a connection to that drinking establishment. Since the *Mirror* also mentions that it was later known as the Cullity Block, I consulted the *Manchester Directory* and found that one Patrick Cullity, a grocer, had both lived in and had his store at 92 Concord Street from the late 1870s until his death in 1884. Due to his late proprietorship of the block that bore his name, it is doubtful that Patrick Cullity had any idea of what lay in his basement. John Jordan agrees—Cullity's innocence and upstanding character seemingly attested by a stained-glass window in his memory above the main altar in Saint Joseph's Cathedral.

Meanwhile, for a Franco-American perspective, I consulted *L'Avenir National* at the Centre Franco-Américain, thanks to Manon Therrien. In a page-one article entitled "Est-ce un meurtre?" (Is It a Murder?), dated August 29, 1899, we learn that the workers who made the gruesome find were Franco-Americans: J. Paradis and S. Gagnon. The rest of the article, which makes no mention of the drainpipe, is otherwise similar in nature to its English-language counterpart, with one contradictory exception: it states that the skull bore no trace of a fracture and therefore dismisses any talk of murder as mere speculation.

As did the *Mirror*, *L'Avenir* published a follow-up news item on August 31. Entitled "Une explication. Le squelette d'une jeune fille" (An Explanation. The Skeleton of a Young Girl), the page-one article offers entirely new information. Now, the newspaper had reversed its position. According to Manchester police, a Mrs. Emily Newton believed that she knew the truth. Born in Lowell, Massachusetts, in 1816, she had traveled by stagecoach through Manchester in 1827 on her way to Hanover. Though only eleven at the time, she recalled that a fellow passenger, a Doctor Crosby, also from Lowell, had pointed out a building in Manchester, allegedly the scene of a mysterious occurrence. Apparently, an extremely beautiful eighteen-year-old woman had lived there with a man to whom she was not legally

married. The woman's eventual disappearance had made New England–wide headlines. Nonetheless, despite the passage of seven decades, the case remained not only unsolved but altogether forgotten. While the article's tone lends credibility to Mrs. Newton's theory, several historical errors and questionable details cast doubt upon her story.

At any rate, Lambert used the macabre unearthing as a springboard for his complex plot, albeit with a few changes, including the age of the woman at the time of her demise, to suit his fictional needs.

Interestingly enough, the structure that replaced the one demolished in 1899 later housed the Granite State Press where, for a time, Alfred DeRepentigny, a printer and the father of *Peyton Place* author Grace Metalious, once worked. Lambert and Metalious are among a handful of writers who have used Manchester as the setting for their fiction, though Metalious calls the city Livingstone in her final novel, *No Adam in Eden* (1963). In 1955, the Granite State Press vacated the premises, along with all other business and residential owners on the same city block, to make way for the Hartnett Parking Lot, which has remained since 1956.

It is my hope that this information will give readers a taste of what Adélard Lambert—through Margaret Langford's translation—has reserved for them. These readers might include, among others, lovers of historical fiction or of mysteries, students of Québécois or immigration history, Civil War enthusiasts, New Englanders, Franco-Americans, residents of Manchester or of Lowell—where more of the action takes place—and anyone else seeking a few hours of literary enjoyment.

At last, this cleverly crafted though all-too-brief page turner will reach well beyond its up-to-now limited Francophone readership. Moreover, by having invited me to write the present foreword to her translation, Professor Langford has given me the opportunity to share the story of my attachment to Lambert's novella and to the world he created and left behind, in which I labored with love some thirty years after his death.

From *L'Innocente Victime* to *The Innocent Victim*, Margaret Langford, in collaboration with Claire Quintal, has given new life to an old favorite.

Author's note: The Innocent Victim *was published in 2008 by Images from the Past in Bennington, Vermont.*

REVISITING EIGHT THOUSAND FRIENDS

May through August is a time for working on my own projects at a picnic table in my "summer office," a shady corner behind our home. But not in 2009. Although last summer's persistent rainy weather meant working indoors, I was only too happy to oblige. I was spending time with old friends—eight thousand of them.

At the request of Betsy Holmes, collection/user services librarian at St. Anselm College's Geisel Library, I agreed to select three thousand volumes from a recent gift totaling eight thousand. The mostly French-language collection once belonged to L'Association Canado-Américaine, where I served as librarian-archivist from 1975 to 1982. It had been purchased by the ACA Library Preservation Consortium, LLC, and placed in our library to be reorganized, preserved and accessible. Whatever books the Geisel Library doesn't keep will be made available to other research libraries.

After twenty-seven years, the old leather-bound and paperback friends I'd cared for and cherished had followed me from the ACA to Saint Anselm College—where I teach conversational French—like a parade of stray cats in search of a new home. Even before my first day on the job, I knew that, in addition to performing a professional service for the library, I was about to embark on a spiritual journey into my past. Some of the works in the collection related not only to familiar surroundings but also to my own ancestors. Originally known as "La Collection Lambert," it owed its existence to Adélard Lambert, a Manchester tea and coffee salesman who,

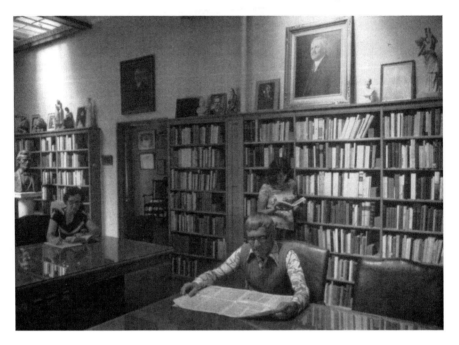

A corner of the ACA library, 1977. *Photo by Robert B. Perreault.*

between 1899 and 1918, collected approximately four thousand books from his customers, which he sold to the ACA upon his retirement.

Since 1918, the collection has grown, thanks to numerous donors, including its most generous benefactor, the late author and historian Monsignor Adrien Verrette, who enriched it with several thousand works of history, sociology, politics, religion, literature and genealogy from French North America and France.

As I made my way through the rows of books in the Geisel Library basement to begin my selection, I recognized certain old friends not only by the titles and authors on their spines but also by their color and size; they practically jumped off the shelves and into my hands as if saying, "Remember me? Please take me." In my initial sweep, I picked every New England Franco-American book, from the second edition (Montréal, 1888, but originally published in Fall River in 1878) of journalist Honoré Beaugrand's *Jeanne la Fileuse* (Joan the Spinner), the first novel by a Québécois immigrant in New England, to Biddeford writer Normand Beaupré's book of Maine legends, *Lumineau* (2002). Later, I selected

significant works from the rest of French North America as well as those from France that deal with the region.

Whether reading for research purposes or for pleasure, visitors will find prominent and lesser-known names among the fiction and nonfiction authors lining the shelves: Marie de l'Incarnation, François-Xavier Garneau, Laure Conan, Louis Fréchette, Gabrielle Roy, Lionel Groulx, Germaine Guèvremont, Robert Rumilly, Anne Hébert, Gilles Vigneault, Marie-Claire Blais, Pierre-Elliott Trudeau, Antonine Maillet, Félix Leclerc and hundreds more.

A few works that stand out due to their local and regional interest include former Manchester mayor Josaphat T. Benoit's two published doctoral dissertations, *Rois ou Esclaves de la Machine?* (Kings or Slaves of the Machine?) from L'Université de Montréal and *L'Âme franco-américaine* (The Franco-American Soul) from the Sorbonne; Cyrille Vaillancourt and Albert Faucher's *Alphonse Desjardins: Pionnier de la coopération d'épargne et de crédit en Amérique*, a biography of Canada's credit union movement founder, who also oversaw the creation of the first such institution in the United States, La Caisse Populaire Sainte-Marie/Saint Mary's Bank, in Manchester in 1908; a memoir entitled simply *81490*, the concentration camp inmate number of Albert Chambon, a French Catholic survivor of Buchenwald, who eventually served as consul general of France in Boston; the now classic Franco-American novels *Papa Martel* and *The Apple of His Eye* by Maine writer Gérard Robichaud, who died in 2008 at age one hundred; and a book of special importance to the Anselmian community, *Just Off the Aisle: Ramblings of a Catholic Critic* by Nashua-born Saint Anselm alumnus Richard A. Duprey.

Among the collection's one-of-a-kind items is a handwritten letter dated 1919, in which the secretary of the students at the all-girls' Académie Villa Augustina in Goffstown thanked Adélard Lambert for his donation of books by Bossuet, Racine and other classic authors to the newly opened school's library. The letter's author, Manchester native Clarisse Gaudette, who became Mère Marie Cécilia, r.j.m., made international headlines when, at age 106, she cast her absentee ballot for Barack Obama from her residence, the Mother House of the Religious of Jesus and Mary in Rome. Her order's worldwide oldest living member, she continues (as of October 2009) to enjoy relatively good health at age 107.

To my surprise, folded in a 1931 novel entitled *Nord-Sud* (North-South) by Québécois author Léo-Paul Desrosiers, I found two letters. One is a

typewritten carbon copy addressed to Desrosiers by my maternal grandfather, Adolphe Robert, longtime editor of the ACA's publication, *Le Canado-Américain*, as well as the ACA's fourth president. In it, my grandfather praised the then young writer for his evocative portrayal of the region where both men had grown up. The second letter is Desrosiers' original handwritten response thanking my grandfather for his kind words.

Through this project, I also became acquainted with books donated to or acquired by the ACA library since my departure. They include a history of the Sisters of Holy Cross, with cover art by Sister Liliosa Shea, my teacher in grades four through six at L'École St. Georges in Manchester, who later headed the art department at Notre Dame College. There are also several books that analyze Québec's Révolution Tranquille (Quiet Revolution) of the 1960s and its influence on the province's independence movement. My most moving moment was my discovery of several dozen books donated by the family of the late Doctor Robert G. LeBlanc, professor of geography at the University of New Hampshire, who died in the second plane that crashed into the World Trade Center on September 11, 2001. Bob often did research at the ACA and once had me give his students a tour of Manchester's Franco-American West Side. Among his books, I found his typescript of a book review that he apparently had intended to submit to a Canadian geographical journal.

The value of the ACA/Lambert/Franco-American Collection is already evident. During the selection process, one of my advanced conversational French students from Manchester, Angela Bossio, who is Franco-American on her mother's side, began cataloguing the volumes I was setting aside to keep. She told me that by handling the books to obtain their bibliographical data, she was learning much about her cultural background, whose literary output she hadn't realized was so rich. Likewise, when Angela left her position to take part in the college's summer program in Paris, her replacement, Catherine Martel, was stunned and thrilled upon opening a book on nineteenth-century Lewiston, Maine, that featured images and descriptions of her paternal ancestors. The collection is not even catalogued and available to the public, and already we've received phone calls and e-mails about its current status. Most recently, a member of the American-Canadian Genealogical Society contacted the college in hope of having the collection open to him at this early stage.

Vivre la Différence

I dream of a day when researchers from throughout the North American French community will visit the collection; when Saint Anselm students and faculty will use its resources as part of their course work in French, history, sociology, theology, politics, humanities and other disciplines; and when prominent scholars and writers in the field of North American French studies—and especially New England Franco-American culture—will be invited to speak on campus.

Finally, I shall forever be grateful to the members of the ACA Library Preservation Consortium, who purchased La Collection Lambert for donation to the Geisel Library. I am equally thankful to the library's staff, who made my work efficient and pleasurable. Thanks to all, this unique collection will remain in local hands, accessible to professionals and amateurs alike for the foreseeable future.

Author's note: On August 18, 2010, nearly one year after the above article was published, the Geisel Library officially inaugurated the ACA/Lambert/Franco-American Collection in the presence of library staff, faculty, scholars and guests from New England and Québec. Meanwhile, word from Rome announced that Mère Marie Cécilia Gaudette, now age 108, is "as mentally sharp as ever, somewhat frail, but generally in good health. She comes to Mass each day, is in the dining room for meals, plays cards—winning more than losing—and is a vital and dearly loved member of our community."

BIBLIOGRAPHY

Anctil, Pierre. *Fais ce que dois. 60 éditoriaux pour comprendre* Le Devoir *sous Henri Bourassa*. Québec City, Canada: Les Éditions du Septentrion, 2010.
———. *A Franco-American Bibliography: New England*. Bedford, NH: NMDC, 1979.
L'Avenir National. Manchester, NH, multiple years.
Belisle, Alexandre. *Histoire de la Presse Franco-Américaine et des Canadiens-Français aux États-Unis*. Worcester, MA: Ateliers Typographiques de "L'Opinion Publique," 1911.
Benoit, Josaphat. *L'Âme franco-américaine*. Montréal, Canada: Éditions Albert Lévesque, 1935.
———. *Ferdinand Gagnon: biographie, éloge funèbre, pages choisies*. Manchester, NH: 1940.
Brault, Gérard J. *The French-Canadian Heritage in New England*. Hanover, NH: University Press of New England, 1986.
Chartier, Armand. *The Franco-Americans of New England. A History*. Translated by Robert J. Lemieux and Claire Quintal. Manchester, NH: ACA Assurance, and Worcester, MA: Institut français of Assumption College, 1999.
Daignault, Elphège-J. *Le Vrai Mouvement Sentinelliste en Nouvelle-Angleterre 1923–1929 et l'Affaire du Rhode Island*. Montréal, Canada: Les Éditions du Zodiaque, 1936.
Foisy, J.-Albert. *Histoire de l'Agitation Sentinelliste dans la Nouvelle-Angleterre 1925–1928*. Woonsocket, RI: La Tribune Publishing Company, 1928.

Hareven, Tamara K. *Family Time and Industrial Time: The Relationship Between the Family and Work in a New England Industrial Community*. Cambridge, England: Cambridge University Press, 1982.

Hareven, Tamara K., and Randolph Langenbach. *Amoskeag: Life and Work in an American Factory-City*. New York: Pantheon Books, 1978. Corrected paperback edition.

Lambert, Adélard. *The Innocent Victim*. Translated by Margaret Langford. Bennington, VT: Images from the Past, 2008.

———. *L'Innocente Victime*. Bedford, NH: NMDC, 1980.

———. *Journal d'un bibliophile*. Drummondville, Québec, Canada: Imprimerie La Parole Limitée, 1927.

Malouin, Reine. *Où chante la vie*. Québec City, Canada: Éditions de L'Action Catholique, 1962.

Manchester City Directory. Boston: R.L. Polk & Co., multiple years.

Manchester Daily Mirror & American. August 28 and August 31, 1899.

Manchester Directory. Boston: Sampson & Murdock Co., multiple years.

[Metalious], Grace de Repentigny. "Fuller Brush Man." *The Oracle*, Manchester Central High School (November 1942): 27–28.

———. *No Adam in Eden*. New York: Trident Press, 1963.

The Oracle. Manchester Central High School, January 1942.

Paradis, Wilfrid Henry. "French-Canadian Influence in Manchester, N.H. Before 1891." MA thesis, St. Mary's Seminary, Baltimore, Maryland, 1949.

———. *Upon This Granite: Catholicism in New Hampshire 1647–1997*. Portsmouth, NH: Peter E. Randall Publisher, 1998.

Perreault, Robert B. "Before Dan Brown Came Grace Metalious: *Peyton Place* Turns 50." *Book Notes* (Center for the Book, State Library, Concord, NH) 2, no. 2 (Fall 2006): 4–5, 7.

———. "Daignault, Elphège J. (1879–1937)." In *Making It in America: A Sourcebook on Eminent Ethnic Americans*, edited by Elliott R. Barkan, 83–84. Santa Barbara, CA: ABC CLIO, 2001.

———. "Les dernières années d'une école paroissiale franco-américaine: un témoignage personnel." In *Les Franco-Américains et leurs institutions scolaires*, edited by Claire Quintal, 333–52. Worcester, MA: Institut français, Assumption College, 1990.

———. *Elphège-J. Daignault et le Mouvement Sentinelliste à Manchester, New Hampshire*. Bedford, NH: NMDC, 1981.

———. "The 'Father of the Franco-American Press.'" *Manchester Journal*, June 6, 1984, 10–11.

———. "Les Franco-Américains/The Franco-Americans" in "Du Québec à la Nouvelle-Angleterre/Emigration: A Franco-American Experience." *Le Magazine Ovo/Ovo Magazine* (Montréal) 12, no. 46 (1982): 14–17. Separate but identical French and English editions.

———. "A Franco-American Experience." *Manchester Journal*, November 30, 1983, 1, 2, 10, 23.

———. "Une île francophone dans une mer anglophone: les Franco-Américains du Nord-Est." *Cahiers bleus* (Troyes, France), nos. 36/37 (Winter–Spring 1986): 106–8.

———. "In the Eyes of Her Father: A Portrait of Grace Metalious." *Historical New Hampshire* (Concord, NH) 35, no. 3 (Fall 1980): 318–27.

———. "A Man of Mechanics: He Was Born to Be a Master of His Craft." *Manchester Journal*, April 11, 1984, 1, 20–22.

———. "A New Life for an Old Favorite." Foreword to *The Innocent Victim*, Margaret S. Langford's Translation of Adélard Lambert's novel *L'Innocente Victime*, ix–xvi. Bennington, VT: Images from the Past, 2008.

———. "A Photographic Legacy." *Manchester Journal*, January 2, 1985, 1, 8–11, 21,

———. "Revisiting 8,000 Friends: Perusing Geisel Library's Franco-American Collection." *Portraits, The Magazine of Saint Anselm College* 51, no. 1 (Fall 2009): 25–27.

———. "Ulric Bourgeois, artiste-photographe: Des images retrouvées du temps perdu." *Liaison* (Ottawa, Ontario), no. 42 (Spring 1987): 28–31.

———. "West Side Story." *Manchester Magazine*, in two parts: 1, no. 4 (November 1987): 28–32; 1, no. 5 (December 1987): 32–35.

Plante, David. *The Country*. New York: Athenaeum, 1981.

Robert, Adolphe. *Henri d'Arles, étude critique*. Québec, Canada: Le Canada Français, 1943.

———. *Un Lettré Illettré: Étude sur Adélard Lambert, collectionneur et folkloriste*. Joliette, Québec, Canada: Les Carnets Viatoriens, 1944.

———. *Mémorial des Actes de L'Association Canado-Américaine*. Manchester, NH: L'Avenir National, 1946.

Samson, Gary. *A World Within a World: Manchester, the Mills, and the Immigrant Experience*. Dover, NH: Arcadia Publishing, 1995.

Le Semi Centenaire. Manchester, NH: Fitzpatrick & Flood, Imprimeurs, 1896.

Bibliography

[Sulte, Benjamin]. *Ferdinand Gagnon, sa vie et ses oeuvres.* Worcester, MA: C.-F. Lawrence & Cie, Imprimeurs, 1886.

Tardivel, Émile. *Le Guide Canadien-Français de Manchester, N.H. Pour 1894–95.* Manchester, NH: La Cie John B. Clarke, Éditeur, 1894.

Thoreau, Henry David. *Walden or, Life in the Woods.* New York: Signet Classics, n.d.

Toth, Emily. *Inside Peyton Place: The Life of Grace Metalious.* Garden City, NY: Doubleday & Company, Inc., 1981.

[Verrette, Reverend Adrien]. *Paroisse Sainte-Marie, Manchester, New Hampshire. Un cinquantenaire 1880–1930.* Manchester, NH: Imprimerie Lafayette Inc., 1931.

———. *Paroisse Saint-Georges, Manchester, New Hampshire.* Manchester, NH: various dates. Series of seven booklets on Saint-Georges Parish's history and contemporary events, published annually or sporadically between 1960 and 1970.

INDEX

A

Académie Notre-Dame 41
ACA library 121, 122, 123, 124, 125, 129, 130, 132
Action, L' 33, 90
Albert, Renaud 125
American-Canadian Genealogical Society 24, 132
America's Credit Union Museum 103
Amoskeag (book) 93
Amoskeag Industries 21
Amoskeag Manufacturing Company 16, 18, 20, 21, 26, 28, 29, 39, 65, 72, 93, 111, 112, 113
Amoskeag Millyard 22, 96, 100
Arles, Henri d' (Rev. Henri Beaudé) 41, 42, 122
Ash Street School 62, 68, 70, 75
Association Canado-Américaine (ACA) 19, 24, 42, 55, 56, 59, 60, 62, 65, 121, 122, 123, 124, 125, 129, 132
Avenir National, L' 19, 21, 33, 41, 64, 65, 125, 127

B

Benoit, Josaphat T. 36, 122, 131
Biron Bridge, Nazaire 98
Bishop Bradley High School 58
Blais, Roger 93
Boivin, Attorney Joseph 103
Bonjour! (French TV program) 24
Boucher, Anna-Émilia (née Saint-Denis) 26
Bourgeois, Antoinette 37, 39, 40, 41, 42, 43, 44, 46
Bourgeois, Ulric 16, 17, 26, 27, 37–46
Bradley, Bishop Denis 52

C

Caisse Populaire Sainte-Marie, La (Saint Mary's Bank) 19, 102, 103, 131
Canado-Américain, Le 34, 65, 132
Carpenter Memorial Library 72, 126
Catholic Medical Center (CMC). *See* Notre-Dame-de-Lourdes, Hôpital

INDEX

Centre Franco-Américain 16, 24, 121, 127
Chase Tea Company, E.M. 121
Chevalier, Rev. Joseph-Augustin 51
Chez-Nous (French radio program) 23
Clarke Press 65, 67, 118
Clément de Rome, Sr. Marie 82
Collection Lambert 122, 129–133
Cullity Block 127

D

Daignault, Elphège J. (Atty/Judge) 55, 56, 57, 59
Delaney, Bishop John 52
Dennis, Steven 81
DeRepentigny, Alfred 63, 64, 65, 67, 68, 128
DeRepentigny, Laurette (née Royer) 63, 64, 65, 66, 67, 68, 69, 71
Desjardins, Alphonse 103, 131
Devoy, Thomas J.E. (Rev./Msgr.) 53, 54, 55, 56, 57, 59, 63, 64, 71, 77, 87, 89

E

East Side 18, 19, 96, 107, 121
Écho de Notre-Dame, L' 101
École Saint Georges Apartments 90
Einstein, Ernest 70
"Escalier interdit, L'" (short story) 91

F

Farley, Irène 48
Farley, Paul 48
Festival de la Bonne Chanson 79
Fitzpatrick, Laterrière 48
Fitzpatrick, Lucie 48

Flat Iron district 18, 31, 96, 100, 101, 102
Flatte, Le (Whittemore Flats) 18, 19
Fuller Brush Man (short story) 70, 75

G

Gagnon, Ferdinand 31–36, 95, 122
Gagnon, René 22
Gaudette, Clarisse (Mère Marie Cécilia, r.j.m.) 131, 133
Geisel Library (Saint Anselm College) 129, 133
Gosselin, Lucien 88
Granite State Press 65, 128
Guertin, Georges-Albert (Rev./Bishop) 53, 54, 55, 56, 59

H

Habitant Soup Company 22
Hareven, Tamara K. 93
Hebert, Ernest 64
Hévey, École (school) 29
Hévey, Pierre (Rev./Msgr.) 51, 52, 53, 103

I

Innocente Victim, L'. See *Innocent Victim, The*
Innocent Victim, The 121–128
Irish Americans 47–60, 69, 79, 91, 96

J

Jordan, John 126, 127
Journal d'un bibliophile 123

K

Know-Nothing Party 48

Index

L

Lacerte, Roger 23
Lafayette Park 31, 36, 95
Lambert, Adélard 121–128, 129
Lambert, Charlie (The Hermit) 44, 45
Langenbach, Randolph 93
Langford, Margaret 126, 128
LeBoutillier, Corinne 41
LeBoutillier, Jean-Georges 41
Leclerc, Violette 104, 105, 107–113
Léonard, Sr. Alice (Sr. Alice des Anges) 80, 84
Lessard, Attorney Wilfrid 15, 16
Lettré Illettré, Un 123
Librairie Populaire, La 23, 24
Limoges brothers, Albert & Rémi 22
Lussier, Blanche 41

M

Manchester Central High School 48, 69, 70, 71, 73
Manchester Daily Mirror & American 126, 127
McConnell, Georgianna (née DeRepentigny) 67, 68, 71
McDonald, Rev. William 51
McDonald School 81
McGregorville 18
Metalious, George 71, 72, 73
Metalious, Grace (née DeRepentigny) 61–76, 128
Monseigneur Napoléon Gilbert Park 103
Moreau, Arthur E. 21
Morin, Philias 22

N

National Materials Development Center for French (NMDC) 24, 88, 125
No Adam in Eden 63, 64, 65, 67, 69, 71, 72, 75, 128
Normand Brothers' Bakery 111
Normand, Georges 111
Notre Dame Bridge 97, 98
Notre Dame College 85, 132
Notre-Dame-de-Lourdes, Hôpital (CMC) 63, 112
Notre-Dame neighborhood 18, 29, 95, 96, 98, 99, 100, 112

O

Oracle, The 69, 70
Ouellette, Claudette 94, 96, 101, 102
Ouellette, Gilberte 102

P

Pandora in Blue Jeans 75
Perreault, Henry L. 65, 115–120
Perreault, Madeleine (née Robert) 59, 79, 119, 120
Peterson, Bishop John 59
Petit Canada (Little Canada) 18, 63, 98, 106
Peyton Place 61, 62, 63, 64, 67, 71, 72, 73, 74, 75, 128
Pinardville 19, 98

R

Rimmon Heights 106
Rimmon, Rock 99, 100
Robert, Adolphe 59, 60, 65, 123, 132
Rosiers Missionnaires de Sainte-Thérèse, Les 48
Royer, Aglae (née Péloquin) 64, 65, 67

Index

S

Saint Anne's Parish 15, 49, 51, 81
Saint Anselm College 93, 94, 129, 131, 133
Saint-Antoine-de-Padoue Parish (Saint Anthony) 24, 42, 53
Saint-Augustin Parish 18, 41, 51, 59
Saint-Edmond Parish 19
Sainte-Marie's Church (first) 18, 52
Sainte-Marie's Church (second) 18, 29, 52, 53, 95, 99, 100, 104, 112
Sainte-Marie's Parish 18, 52, 103, 112
Saint-Georges Church 71, 119
Saint-Georges, École (Saint George School) 55, 58, 59, 62, 68, 77–94, 132
Saint-Georges High School for Girls 57
Saint-Georges, Manoir (Saint George Manor) 82
Saint-Georges Parish 53, 55, 63, 77, 89, 90, 94
Saint-Jean-Baptiste Parish (Parish of the Transfiguration) 19
Saint Joseph's Cathedral 52, 127
Saint Joseph's School 58
Saint Mary's Bank. *See* Caisse Populaire Sainte-Marie
Samson, Gary 37, 39, 46
Sentinelle, La 55, 56, 57, 77
Sentinelliste conflict 54, 55, 56, 59, 87
Sentinellistes 55, 56, 58, 77, 87
Shea, Sr. Liliosa 80, 84, 85, 86, 132
Sisters of Holy Cross 77, 132
Sisters of Mercy Convent 49
Société Saint-Jean-Baptiste 18, 32
Stahl, Dr. David 70
St. Pierre, Msgr. Léo 64

T

Train de la Reconnaissance Française (French Gratitude Train) 98, 103, 104
Transfiguration, Parish of the. *See* Saint-Jean-Baptiste Parish
Tremblay, Dr. Adolphe 32

U

Union Leader Corporation 118, 119

V

Vaccarest, Joseph Ernest (Rev./Msgr.) 64
Varick Company, John B. 39, 40, 41, 44
Verrette, Adrien (Rev./Msgr.) 58, 77, 84, 88, 89, 90, 121, 122, 130
Villa Augustina, Académie 42, 131
Voix du Peuple, La 18, 32, 33, 36, 95

W

West Side 16, 18, 19, 29, 31, 36, 58, 63, 72, 95–106, 107, 112, 121, 132
Whittemore Flats. *See* Flatte, Le

ABOUT THE AUTHOR

Since 1973, Manchester native Robert B. Perreault has worked in various capacities—chief research assistant and oral history interviewer for Tamara K. Hareven and Randolph Langenbach, authors of *Amoskeag: Life and Work in an American Factory-City*; librarian-archivist of L'Association Canado-Américaine and assistant editor of *Le Canado-Américain*; freelance writer, public speaker, historical tour guide and photographer—all to promote his hometown's history as well as New England Franco-American culture.

His affiliation with the New Hampshire Humanities Council, first as a project co-humanist and later as a humanist, Humanities-To-Go scholar and book discussion leader, dates back to 1981.

Photo by Claudette Ouellette-Perreault.

His works of nonfiction and fiction, written in French, English or both languages, include five books and more than 150 articles, essays and short stories published in the United States, French Canada or France. He is the author of a French-language novel, *L'Héritage* (1983), whose setting is Manchester's Franco-American community.

About the Author

His most recent book, *Manchester* (2005), is part of Arcadia Publishing's Postcard History Series.

In 1994, the Manchester Historic Association presented him with its Historic Preservation Award for his "Dedication and Commitment to the Preservation of Historic Resources in the City of Manchester, New Hampshire."

He holds a master's degree in French with specialization in New England Franco-American Studies from Rhode Island College (1981) and is a member of the first graduating class in Southern New Hampshire University's Master of Fine Arts in Fiction and Nonfiction program (2008).

Since 1988, he has taught conversational French in the Native Speaker program at his undergraduate alma mater, Saint Anselm College in Manchester.

Also by the author

Booklets
One Piece in the Great American Mosaic: The Franco-Americans of New England
(1976)
The Restoration and Rededication of Weston Observatory (1977)

Books
La Presse Franco-Américaine et la Politique: L'Oeuvre de Charles-Roger Daoust (1981)
Elphège-J. Daignault et le Mouvement Sentinelliste à Manchester, New Hampshire
(1981)
Joseph Laferrière: Écrivain Lowellois (1982)
L'Héritage (novel, 1983)
Manchester (postcard history, 2005)